Creative MARKER ART and BEYOND

INSPIRING TIPS, TECHNIQUES, and PROJECTS FOR CREATING VIBRANT Artwork in MARKER

Walter Foster

Brimming with creative inspiration, how-to projects, and useful information to enrich your everyday life, Quarto Knows is a favorite destination for those pursuing their interests and passions. Visit our site and dig deeper with our books into your area of interest: Quarto Creates, Quarto Cooks, Quarto Homes, Quarto Lives, Quarto Drives, Quarto Explores, Quarto Gifts, or Quarto Kids.

© 2017 Quarto Publishing Group USA Inc.
Artwork and photographs © Lee Foster-Wilson

First Published in 2017 by Walter Foster Publishing, an imprint of The Quarto Group.
6 Orchard Road, Suite 100, Lake Forest, CA 92630, USA.
T (949) 380-7510 **F** (949) 380-7575 **www.QuartoKnows.com**

Walter Foster Publishing titles are also available at discount for retail, wholesale, promotional, and bulk purchase. For details, contact the Special Sales Manager by email at specialsales@quarto.com or by mail at The Quarto Group, Attn: Special Sales Manager, 401 Second Avenue North, Suite 310, Minneapolis, MN 55401 USA.

ISBN: 978-1-63322-339-4

Page Layout: Krista Joy Johnson

Printed in China
10 9 8 7 6 5 4 3

Creative MARKER ART and BEYOND

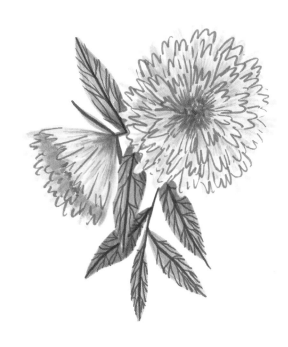

TABLE OF CONTENTS

INTRODUCTION

I drew with markers as a child, and more recently I found myself playing with them with my own children. But I never considered them a tool for creating art. In my mind, they were just for play.

Finding a pack of permanent markers on sale in a local shop helped me rediscover the great joy of drawing with markers. I loved their permanence, colors, and the various ways in which they enabled me to create art. I came to realize that markers are fun, easy tools for making art … and all kinds of art at that!

I got the hang of using markers by challenging myself to create a new drawing every day for 100 days. The twist was that I chose the colors at random by closing my eyes, reaching into my bag of markers, and forcing myself to use the first five colors I chose.

Some of the combinations were easy. The colors flowed together and looked great on the page. Others were downright awful, like the time I selected three different greens, a brown, and a black!

I learned so much over those 100 days. The color challenge helped me expand my knowledge of layering, colors, composition, and drawing, and it made me passionate about markers. They're now my go-to tool, and I've purchased so many that they're starting to take over my studio.

That's because you can do so much with markers! Permanent markers add a wonderful vibrancy to art; paint markers draw on virtually any surface; metallic markers create a subtle; shimmering opulence; and brush markers add a painterly flourish.

After completing the prompts, exercises, and step-by-step projects in this book, I hope that you too will discover the joys of this wonderful tool and find as much enjoyment in markers as I have!

Lee Foster-Wilson

HOW TO USE THIS BOOK

The prompts, exercises, and projects in this book are designed to inspire you to create beautifully illustrated works of art, gifts, home décor, and more using markers. After familiarizing yourself with some of the basic tools and materials you'll want to have readily available, you'll learn fun and easy ways to ignite your creativity. You'll then be invited to try your hand at replicating a variety of patterns, letters, and drawings directly onto the pages of this colorful workbook. From there, the real fun begins as you turn your marks into art!

Browse through this book, and familiarize yourself with its content. You will find an exciting collection of creativity prompts, exercises, and step-by-step projects that will inspire you to be bold with the marks you make and the colors you choose. You will learn how to embrace the restrictions of working with a limited color palette and use that to your advantage when making your artwork. I'll also show you how to create a range of effects with different pens and why you shouldn't throw away the dried-out ones.

I hope that working through the exercises and projects in this book will give you a wide variety of ideas to create exciting finished artworks and gifts using a tool that is often over-looked: the humble marker. Let's get started!

TOOLS & MATERIALS

You can create marker art using a variety of affordable, accessible tools and materials. Here are my essential items.

MARKERS & PENS

Markers come in many colors, tip sizes and types, inks, and finishes. Best of all, they are available almost everywhere. The range can be a little intimidating, so I've chosen a few of my favorite kinds to focus on.

Permanent Markers These come in a dizzying array of colors and tip sizes. For most of my drawings, I like to use permanent markers with a standard bullet tip.

Paint Markers These can be water- or oil-based. Paint markers are opaque and great for drawing on dark materials and glossy surfaces, such as glass and ceramics. Water-based paint markers need to be sealed with a layer of varnish; oil-based ones don't.

Brush Markers Featuring a paintbrush-shaped tip that tapers into a fine point, many brush markers also come with a fine bullet tip at the other end. These are great for creating washes of color and varied line widths.

Metallic Markers Many marker pens also come in a metallic version. My favorite is the paint-marker type, which features a more intense-looking pigment on all surfaces.

Fine-Point Markers A fine point is great for adding extra details to your marker art, particularly if you draw small images.

Water-Based Felt-Tip Pens Cheap and easy tools with which to start your pen collection, water-based felt-tip pens are available in a wonderful range of colors and come in a basic version as well as more sophisticated and longer-lasting versions.

Archival Markers These can be expensive. However, they come in a lovely range of colors and are acid-free, which means they won't damage your surface, making them ideal for marking on photographs and fine-art prints. I like to use Copic brand.

DRAWING SURFACES

The type of paper you use will affect the marks you make. You will find that some pens, especially permanent markers, bleed into certain types of paper. I like to use a smooth card stock for basic drawings and a simple cartridge paper sketchbook for sketching.

You will also need plain copy paper for planning your designs. Tracing paper comes in handy for transferring a sketch to your final surface.

> EXPERIMENT WITH YOUR FAVORITE MARKERS ON DIFFERENT TYPES OF PAPER TO FIND THE ONES THAT WORK BEST FOR YOU.

Markers are great for drawing on a variety of surfaces besides paper, such as wood, glass, and rocks, so you can have those items on hand too if you wish.

SCANNER

Markers are great, no-fuss tools for creating beautiful art, but even permanent markers don't last forever. Their colors can fade over time, so it's always best to scan your favorite pieces to digitally preserve them.

COLOR BASICS

Drawing with markers may seem as easy as picking up a few pens and getting started. But knowing how to make the most of your drawings using color can mean the difference between a flat image that lacks vibrancy and one that really sings!

THE COLOR WHEEL

The color wheel is said to have been invented more than 400 years ago, but it remains the best tool for learning about colors and how they relate to each other on the color spectrum.

At the heart of the color wheel are the three **primary colors**: red, yellow, and blue.

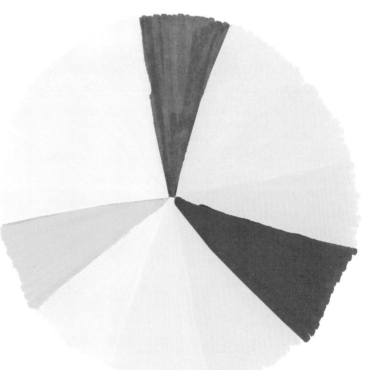

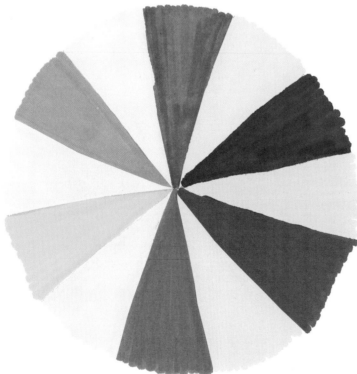

These can be mixed in equal amounts to create the **secondary colors**: orange, green, and violet.

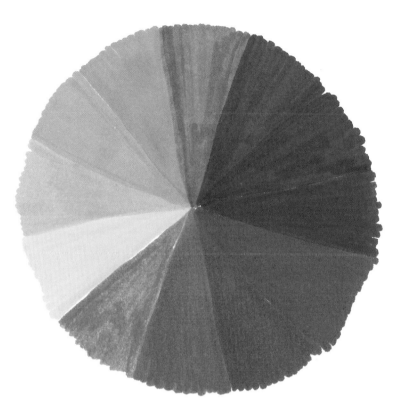

The secondary colors can be mixed to create the **tertiary colors**: yellow-orange, red-orange, red-violet, blue-violet, blue-green, and yellow-green.

Markers can't be mixed like paint, but you can layer them to create secondary and tertiary colors if you're working with a limited palette. For example, yellow can be layered over blue to make green, or over red to make orange. Using different shades of colors will also create different secondary and tertiary colors. Have fun experimenting!

COLOR TEMPERATURE

Colors are classified as warm or cool. **Warm colors** look vivid and energetic and appear to advance in a composition, while **cool colors** are seen as calm and soothing and appear to recede.

USE WARM COLORS TO CREATE DEPTH IN A COMPOSITION.

COLOR SCHEMES

If you're drawing from life, your color choices might be obvious. However, if you're creating an original composition, it can be difficult to decide which colors to use. Should you go warm or cool, vibrant or muted? Consider the color wheel and its color schemes when choosing your colors.

Complementary colors sit on opposite sides of the color wheel. They may appear to clash, but they make for beautiful drawings when used alongside neutrals.

An **analogous** color scheme consists of three harmonious colors that sit next to each other on the wheel. Analogous color schemes are most effective if you choose one dominant color, another one to support it, and a third accent alongside a neutral such as black, gray, or white.

Triadic color schemes are made up of three evenly spaced colors from the color wheel.

KEY COLOR CUES

Even if you use lots of colors to render a scene, certain hues will always dominate. The key to creating a successful, visually pleasing drawing that has impact is to choose certain key colors, with other colors serving as accents. Don't use a whole rainbow of colors in equal amounts (unless you're drawing a rainbow, of course!), or your drawing will lose its visual impact. Be sparing and clever with your colors, and you will create pieces that are a real treat for the eye!

The most important thing is getting to know your pens. Draw a little swatch of each color, or create your own color wheel to use as a reference while drawing.

DRAWING TECHNIQUES

Drawing with markers is as easy as removing the cap and getting started. But to create interesting, engaging drawings that feature different textures and effects, it helps to have a few mark-making techniques in your visual armory. Let's learn how to create marks full of depth, light, and shade.

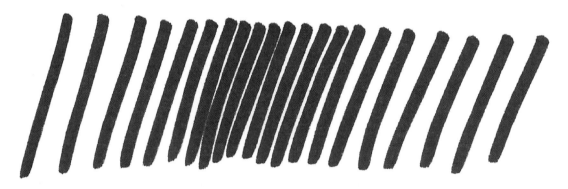

Hatching Drawing straight, parallel lines can create different tones of light and shade. The farther apart and the lighter the lines, the lighter the tone will appear. Heavier lines drawn close together can be used to create dark, shaded areas.

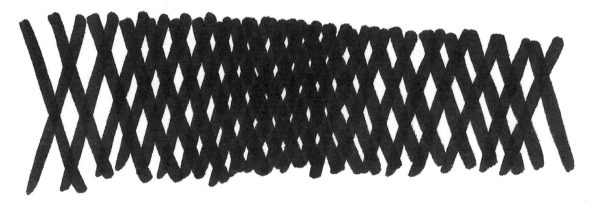

Crosshatching Crosshatching is similar to hatching, but instead of lines drawn in one direction, this technique features lines drawn perpendicularly to a set of hatched lines. It's useful for creating three-dimensional objects and light and shade effects.

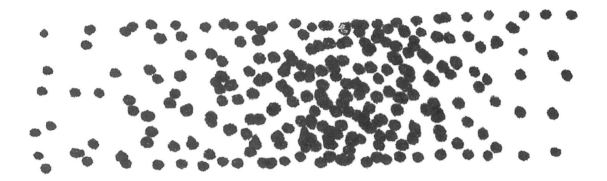

Stippling Stippling uses a series of tiny dots to create form. The closer together the dots, the darker the form.

GRADUALLY SPACE THE DOTS FARTHER APART TO CREATE THE ILLUSION OF LIGHT AND GRADIENT.

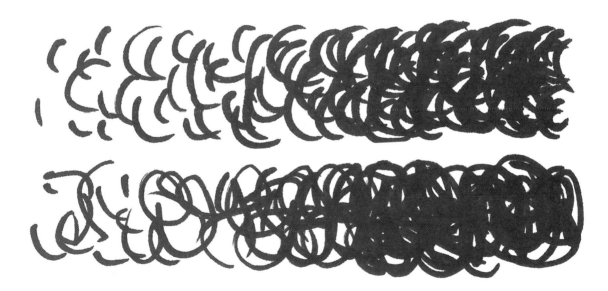

Scumbling Scribble little marks to build up texture and form. Draw them in a range of directions, or use a single circular direction. Make the marks tight and dense or loose and light to create different effects.

Filling This simply means using a pen to color in an area. It can be an effective technique when used with line work and layering.

Shading It can be difficult to shade using markers. Markers that are running out of ink are great for achieving this effect, so don't throw them away! You can apply extra pressure to get more ink out of a pen, or use a softer touch to create lighter shades. See pages 104–108 for more tips on using old markers.

USE A DRYING-OUT MARKER TO ADD THREE-DIMENSIONALITY TO AN OBJECT.

Layering Layer markers of different shades over each other to create new colors (see page 11 for more on this), or layer a single marker to create a subtle variation in tone.

BRUSH MARKERS WORK ESPECIALLY WELL FOR LAYERING.

O.K. O.K. O.K.
O.K. O.K. O.K.

Varying how you hold a marker can help you create different marks. Holding it like a writing tool will give you a standard line, and holding it at the top of the barrel will give you less control but can produce some unexpectedly pleasing results. Using the flat side of the marker's tip creates a heavier, scratchier line, while holding it upright forms a finer line.

All of the examples shown here were drawn using the very same marker. Experiment with your own pens!

MAKE YOUR MARK

You can make lots of interesting marks using markers! For your first exercise, grab a black permanent marker and some white paper, and see what you come up with.

Start by drawing simple lines and shapes, and then experiment with how you hold the pen using just its tip or flat side. How does this change the mark? Try holding the pen at the very top so that you have less control over how it moves, and draw heavy and light lines in a single pattern. Apply more and less pressure with the pen.

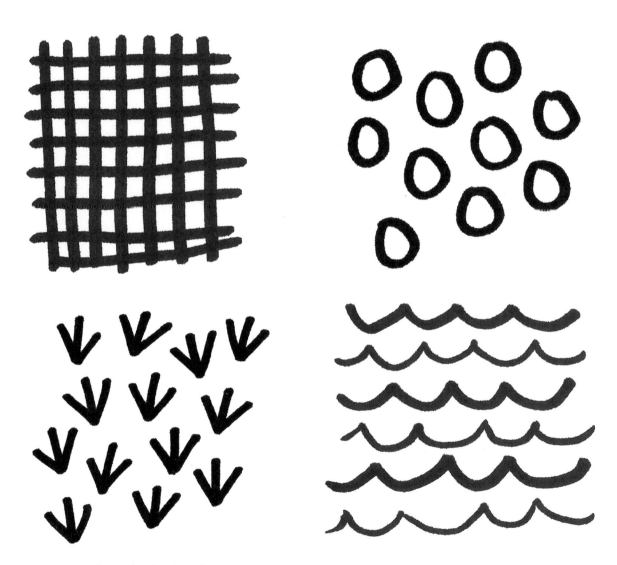

Here are some simple marks that I made using just a black pen. These work well as doodles too!

Now it's your turn! What can you draw using a black permanent marker?

idk

 PRACTICE HERE!

PLAYING WITH COLORS & PATTERNS

One of the greatest things about markers is their wide selection of colors. Markers come in a huge range of colors, but you can't mix and blend them, so you'll have to get creative.

Take a look at your markers. Which colors jump out at you? Pick two or three that you think might work well together, and start making marks. Try layering the colors and creating secondary and tertiary colors within a single pattern. For example, use blue over yellow to create green. (For more on secondary and tertiary colors, see pages 10–11.)

See what happens when you draw the same pattern with one, two, and then three colors. How do clashing colors change the feel of a pattern?

Try alternating two markers within a single pattern for another fun color exercise.

<t PRACTICE HERE!

HAND—DRAWN GIFT WRAP

Add a personal touch to holiday and birthday presents by creating your own gift wrap! The great thing about markers is that you don't need to wait for them to dry—just draw, and then wrap!

TOOLS & MATERIALS

- Large sheets of paper in various colors
- Permanent markers in different colors

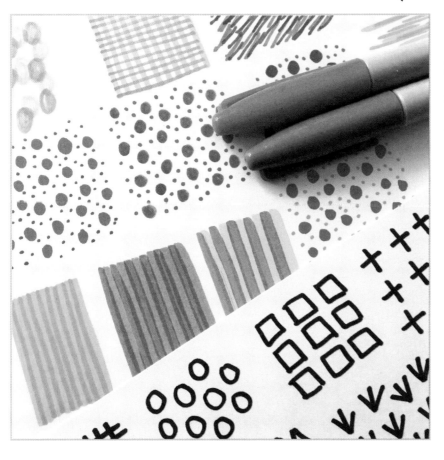

Step 1 Take a look at the marks you made and the colors you used over the last few pages. What stands out? Choose a couple of your favorite marks and color combinations.

Step 2 Now choose four sheets of paper in different colors to go with the markers you already chose. Keep in mind that the colors of the paper will alter the appearance of your markers, so pastel-colored paper might work best unless you've chosen darker markers.

PERMANENT MARKERS WRITE WELL ON LOTS OF DIFFERENT SURFACES. WHY NOT TRY GLITTER OR PEARLIZED PAPER TO ADD SOME PIZZAZZ TO YOUR GIFT WRAP?

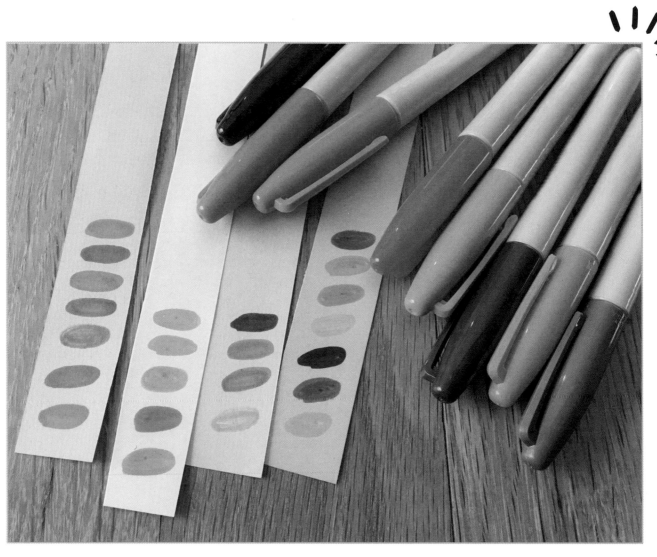

Step 3 Now it's time to play around with your colors! I like to cut a strip from each sheet of paper to test my colors. Here I've chosen to do a bright three-color combination on yellow and pale blue sheets of paper and a more muted two-color combination on pale turquoise and lilac paper.

Step 4 Start drawing! You'll need a big surface for wrapping your gifts, so you might choose to make large marks or space them out to fill the paper quicker. You can also make your marks very intricate—the choice is yours!

IF YOU CHOOSE TO DRAW LINES, AS I HAVE HERE, PULL YOUR ARM FROM THE ELBOW BACK PAST YOUR BODY TO KEEP YOUR LINES STRAIGHT AND CONSISTENT ON A LARGE SHEET OF PAPER.

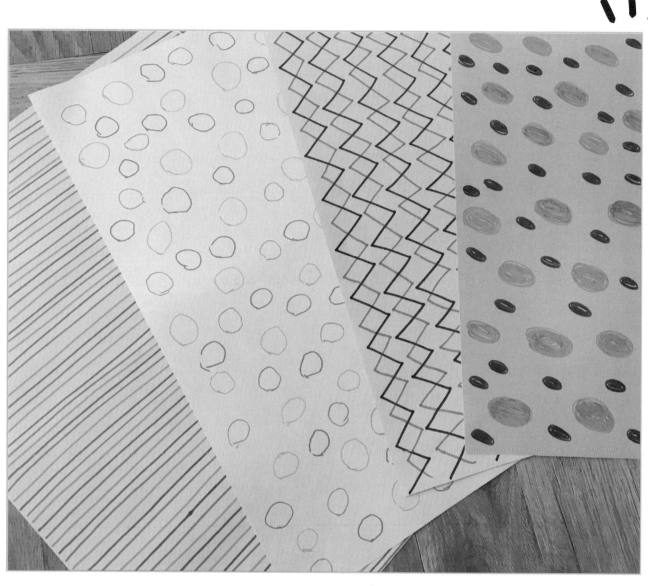

Step 5 Now is the time to make any last-minute changes and additions to your gift wrap! Is the pattern all filled in? Do any areas look bare? Fix them now! Once you are satisfied, wrap your gifts!

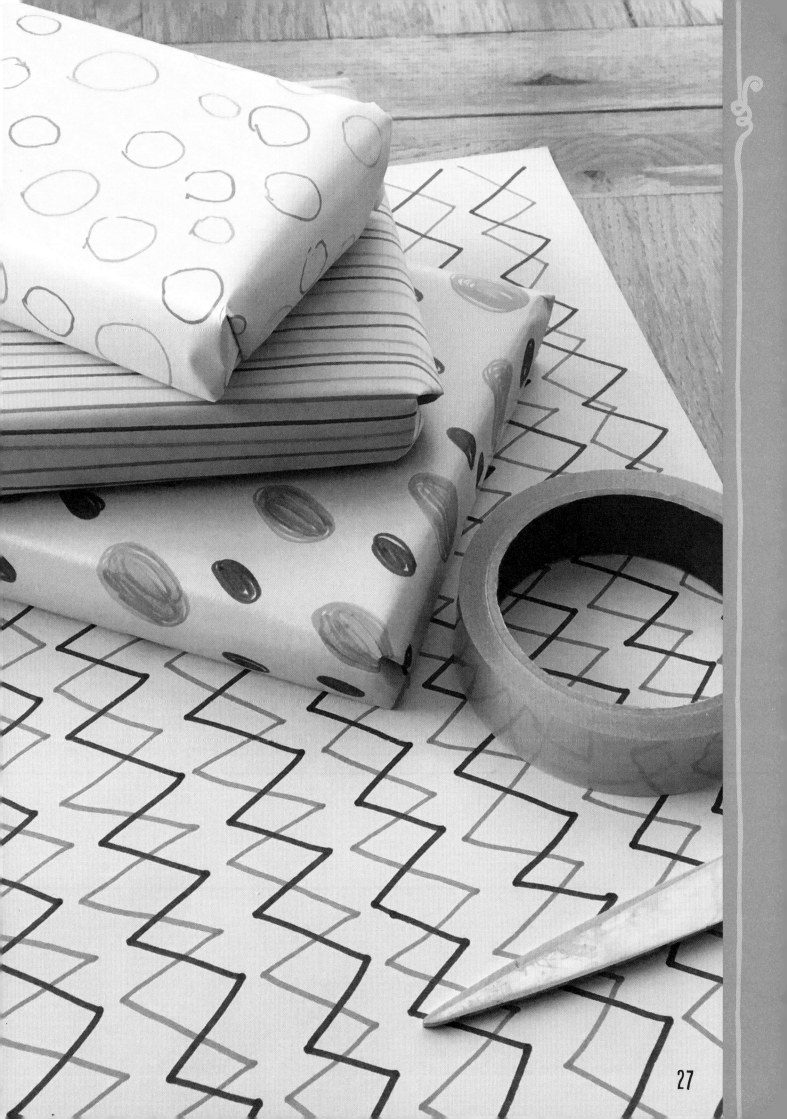

DRAWING INSPIRATION FROM NATURE

I love to draw shapes inspired by nature. Go outside, and see what you can find to draw. A selection of different leaves, a branch with some berries on it, the tiny flowers on a weed, palm fronds… These items and many more make pretty motifs and can inspire beautiful patterns and borders.

Look at the shapes of the leaves, the flowers, and the patterns the leaves' veins make, and choose colors that represent what you see. You may have to get a little creative here depending on your selection of markers. Then try drawing these subjects.

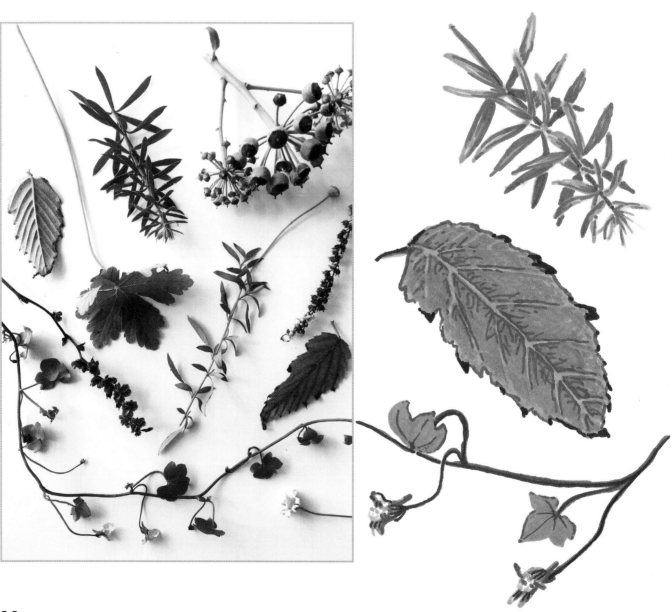

Start with simple drawings, and see how much detail you can create
using a light hand and the pointy part of a marker's tip.

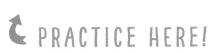 PRACTICE HERE!

SIMPLIFYING SHAPES

One of the things I love most about markers is the strong, well-defined lines they create. They lend themselves to a simpler, more graphic style of drawing, and I like to play this up in my artwork.

Look at the shapes you made on the previous page, and pick out a few favorites. See if you can pare back your drawings to their basic elements and create new, simpler drawings. Perhaps use one or two pens in colors that closely resemble the real-life object that you drew, or try drawing with colors that aren't true to life for an almost magical look. Smooth out the edges to create entirely new shapes, or choose a single detail to repeat instead of drawing all of the details in an object.

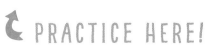 PRACTICE HERE!

ROCKIN' ART

Drawing or painting on rocks is a beautiful technique for displaying your art in an unusual way, and the rocks will look lovely when arranged in groups that feature common themes and colors. They also make great paperweights and sweet, personal, handmade gifts. An added bonus is that they are super fun to make too!

TOOLS & MATERIALS

- Pencil
- Paper
- Smooth rocks to draw on
- Paint pens (I used Uni Posca 0.7 mm paint pens)
- Clear gloss varnish

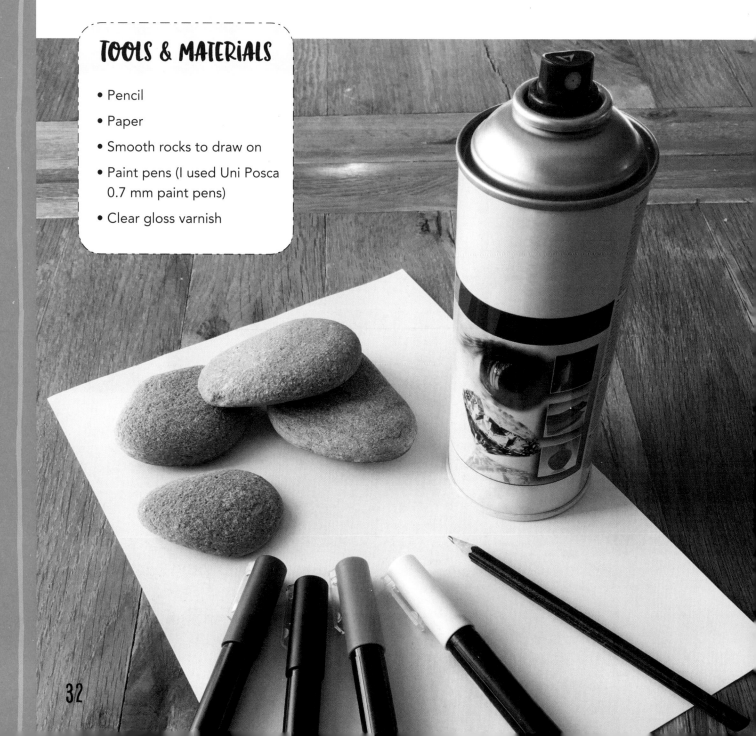

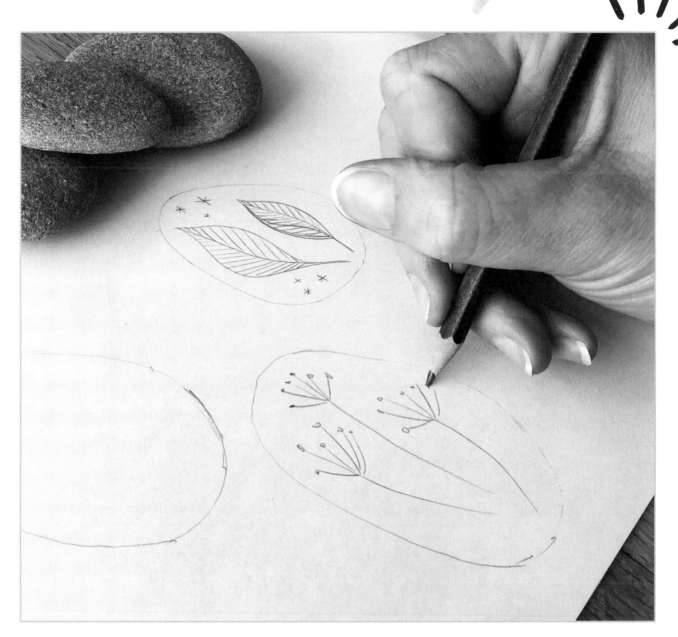

Step 1 Using a pencil and paper, trace around your rocks. This will help you plan your final design. Make some sketches within your outlines, remembering to stay away from the edges to account for the rounded shape of a rock. I drew leaves and flowers to create simple but striking designs.

YOU CAN FIND SMOOTH ROCKS AT MANY BEACHES. GARDEN-SUPPLY STORES ARE GOOD PLACES TO LOOK TOO, AS THEY OFTEN STOCK ROCKS FOR ORNAMENTAL USE.

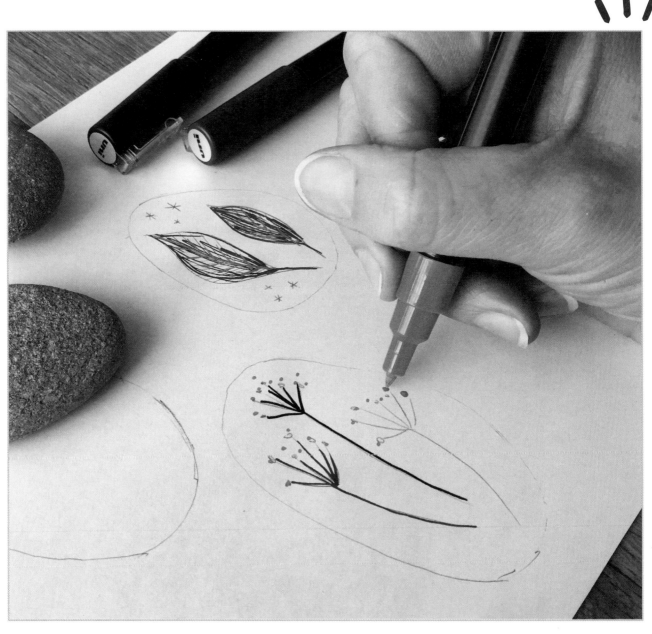

Step 2 Now decide which colors to use. When working with paint pens, you don't have to layer light to dark, as the paint can cover almost anything. Add colors in any order you like!

BEFORE PAINTING DIRECTLY ONTO THE ROCKS, PRACTICE ON A SPARE ROCK TO GET THE HANG OF DRAWING ON A THREE-DIMENSIONAL OBJECT.

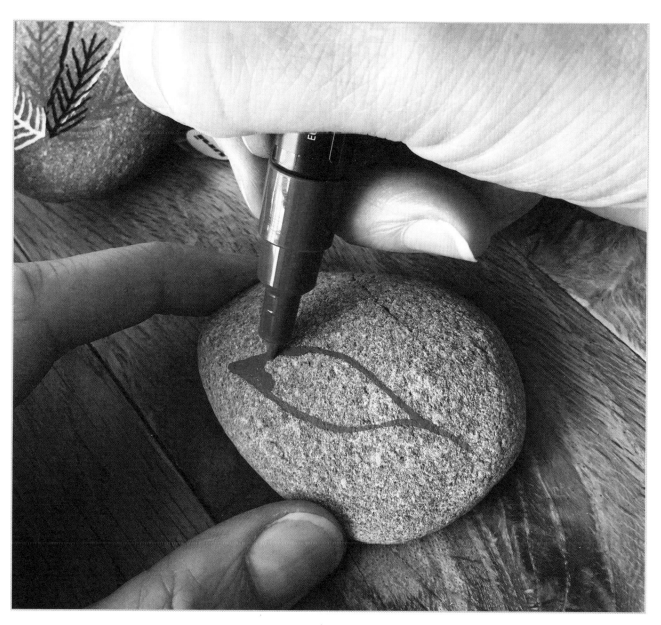

Step 3 Transfer your sketches onto the rocks. Once your drawings are finished, you can protect your designs with a light coat of varnish. This may darken the rocks, so keep this in mind when choosing your colors.

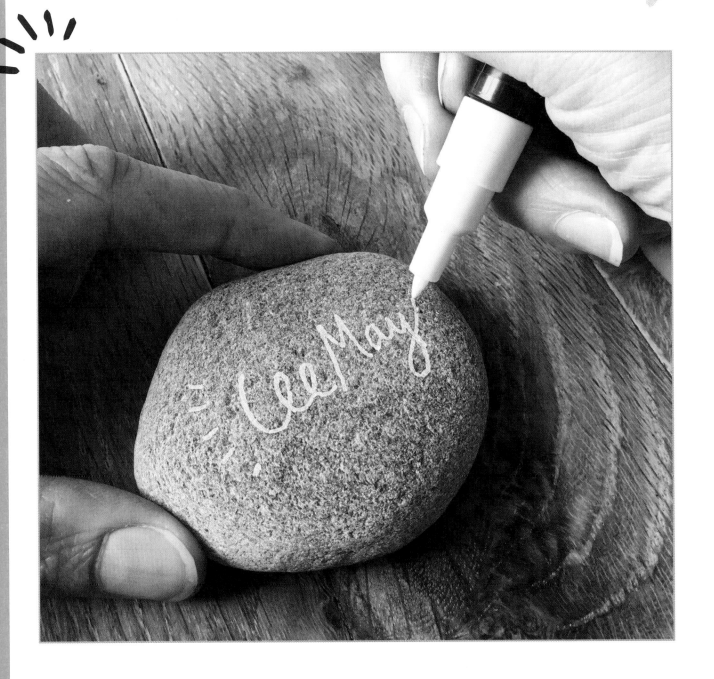

IF YOU WANT TO SIGN YOUR NAME ON YOUR ROCKS, WAIT UNTIL THE VARNISH DRIES, TURN OVER THE ROCKS, SIGN THEM, AND THEN VARNISH THE BOTTOM OF EACH ROCK ONCE THE INK DRIES.

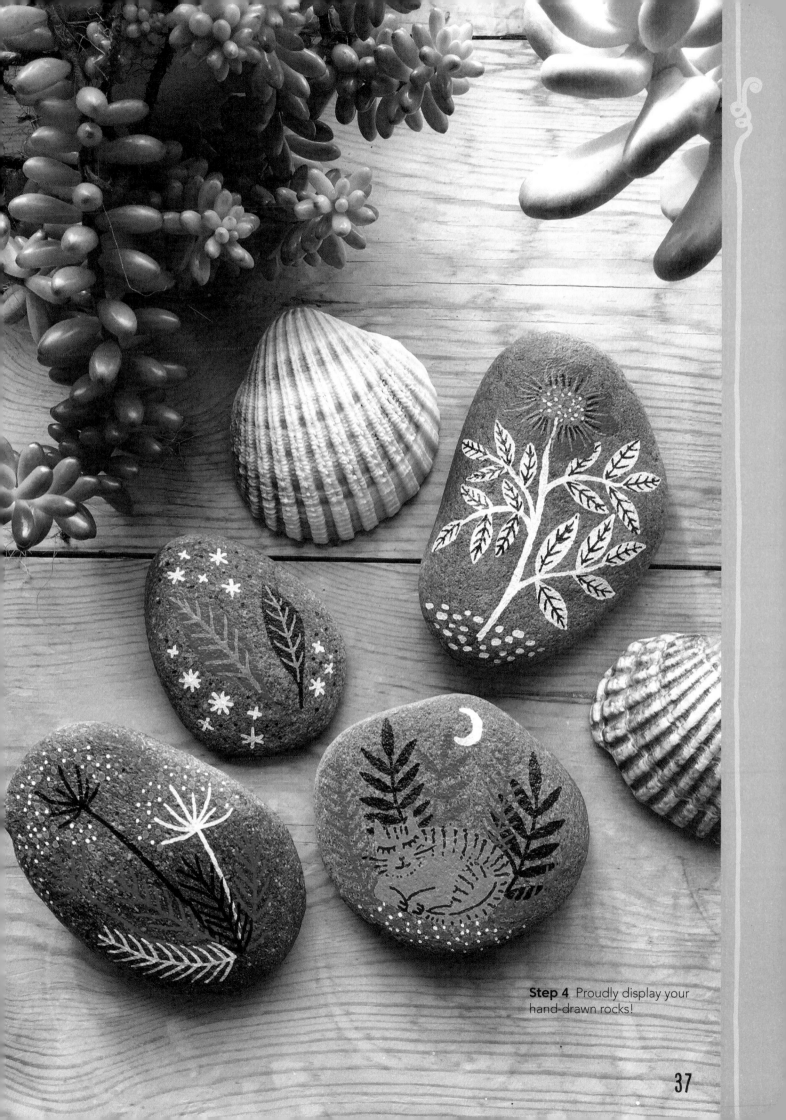

Step 4 Proudly display your hand-drawn rocks!

FROM THICK TO THIN

For an intricate piece, brush markers are a versatile tool. Usually costlier than regular markers, brush markers behave more like watercolor paints and can make a very useful addition to your marker toolbox. I like to use them when I want to add painterly flourishes and softer colors alongside the bright, graphic colors of my other markers.

Use a brush marker to create thick as well as thin lines without removing your pen from the paper. Just angle and turn the nib!

> SOME BRUSH MARKERS ARE STIFFER THAN OTHERS. YOU MAY PREFER A SOFTER NIB THAT BENDS EASILY, OR YOU MIGHT LIKE A STIFFER NIB THAT IS EASIER TO CONTROL BUT DOESN'T CREATE A WIDE RANGE OF MARKS.

A FEW OF MY FAVORITE THINGS

When using brush markers, I especially like drawing the following:

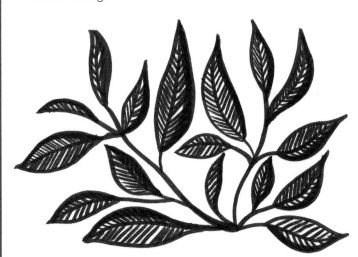

Quick Sketches Achieve painterly, flowing lines very quickly using a brush marker.

Calligraphic Lettering The contrast of thick and thin within one drawn line works well for hand lettering brush-style scripts.

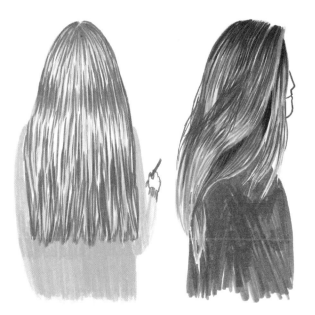

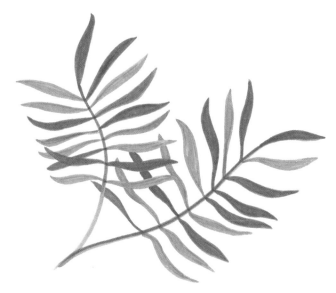

Hair Brush markers come in a wide selection of colors that are close to each other on the color spectrum, which allows you to gradually build depth. This makes drawing soft subjects, like hair, much easier.

Organic Shapes Brush markers are great for capturing the nonuniformity of organic shapes, allowing you to create detailed drawings on a smaller scale.

🐦 PRACTICE HERE!

LAYERS OF DETAILS

Brush markers range in color from extremely pale to very dark, and they come in hundreds of shades.

As with all markers, add your lightest colors first. With brush markers, you can also layer the same color a few times to darken it before adding the next color, making these great tools for creating form, shape, and depth.

Let's start by creating a simple tree using five colors from lightest to darkest.

First, use the scumbling technique (page 15) and your palest color (in this case, gray) to form the shape of a treetop.

Stipple (page 15) and scumble with a slightly darker color, leaving some of the first color peeking through. Concentrate your marks in areas where the leaves should look denser.

With a medium color, add another layer of leaves.

With your darkest marker, add more leaves.

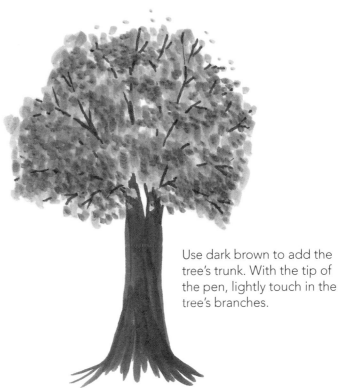

Use dark brown to add the tree's trunk. With the tip of the pen, lightly touch in the tree's branches.

Play around with your brush markers, and try using gentle layers to draw other items.

 PRACTICE HERE!

LAYERING A LANDSCAPE

Landscape art has long been a way for artists to capture their surroundings, and displaying it offers a beautiful way to add a bit of serenity to your home.

By layering gradients of gray and adding a hint of colorful sunshine at the end, you can create a piece inspired by the moment just before the sun sets.

TOOLS & MATERIALS

- Good-quality plain white card stock
- Brush markers in 4 shades of gray plus black
- Markers in black and bright pink or orange, plus matching fineliners
- Picture frame

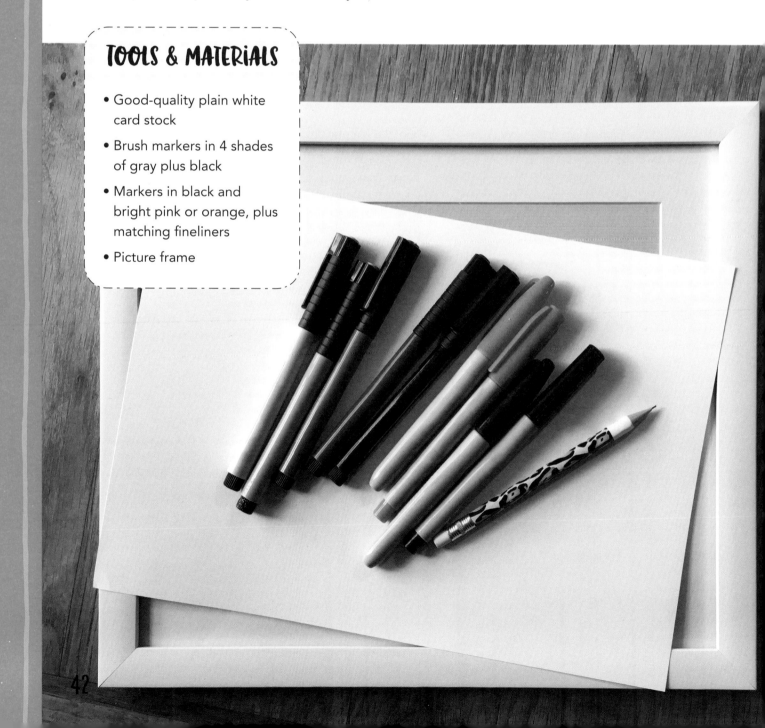

42

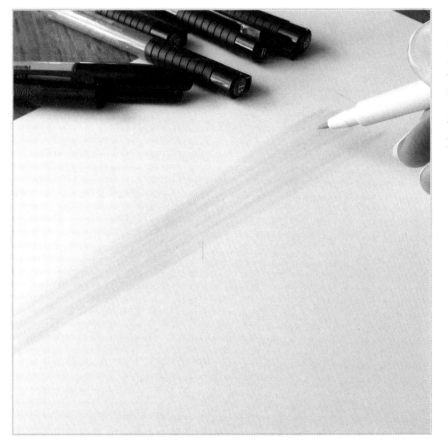

Step 1 First, use your palest shade of brush marker to create the horizon. With gentle, sweeping strokes, move your pen across the paper to build up the horizon and the hills. Keep the color as light as you can.

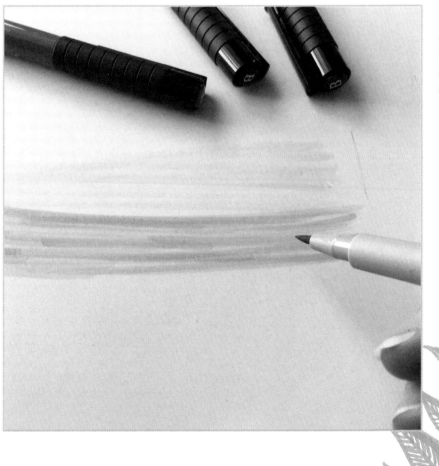

Step 2 Use your next-darkest brush marker to repeat the same strokes and cover the bottom-most strokes from step 1. Remember to imply gently sloping hills and dips.

Step 3 Repeat the same strokes using your next two shades of gray. Continue to use a very light touch, and don't worry if there are little gaps or overlaps in color.

Step 4 Using the corresponding marker for each brush marker, add a second layer to add definition to the hills.

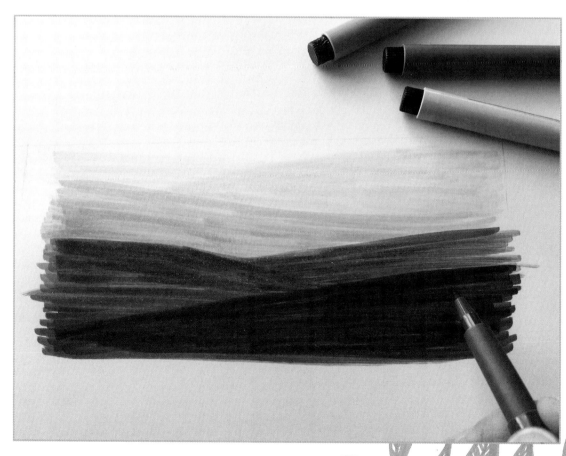

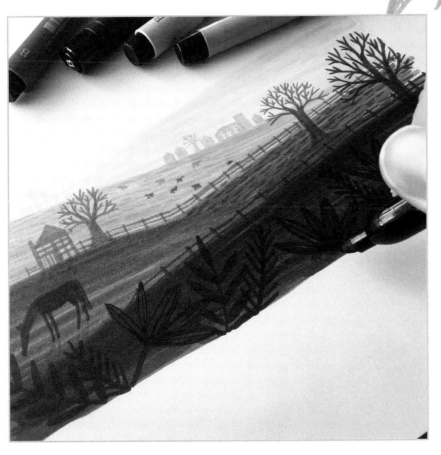

Step 5 Add details, such as houses, trees, fences, and animals. Use the tip of a brush marker and tiny strokes to indicate long grasses and foliage. Then use your black marker to add foreground details.

Step 6 With your bright orange or pink marker, add a stylized sunset. You can draw a sun with rays radiating outward, a white sun on the horizon with a bright sky surrounding it, a glowing orb in the sky, or something else entirely!

Then use a fineliner in the same color to highlight areas that might reflect the sun.

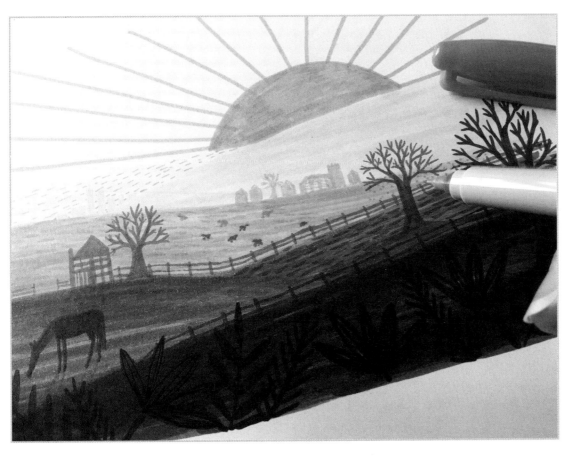

Step 7 Sign your drawing, and then frame it!

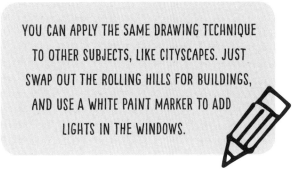

YOU CAN APPLY THE SAME DRAWING TECHNIQUE TO OTHER SUBJECTS, LIKE CITYSCAPES. JUST SWAP OUT THE ROLLING HILLS FOR BUILDINGS, AND USE A WHITE PAINT MARKER TO ADD LIGHTS IN THE WINDOWS.

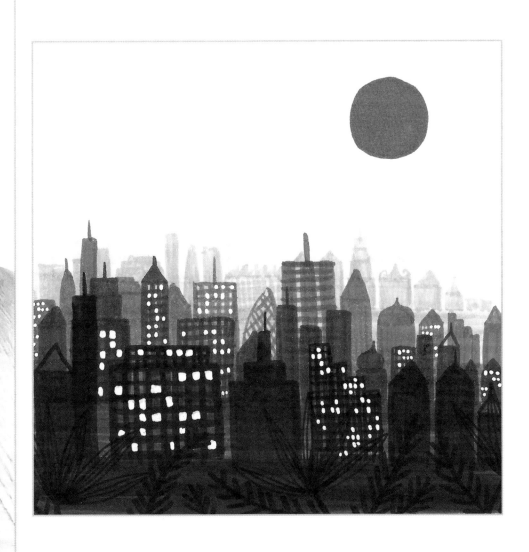

STRIKING SILHOUETTES

Silhouettes are fun to draw, and you can modernize an otherwise traditional-looking silhouette by adding elements of the subject's personality or hobbies.

To create a portrait in silhouette, draw a person's profile, and fill it in. Then have fun embellishing the profile with flourishes and shapes.

You'll want to dig out your blackest marker as well as a black fineliner to add the more intricate details. Remember that everything should be drawn in black, and images of people in profile work best for silhouettes.

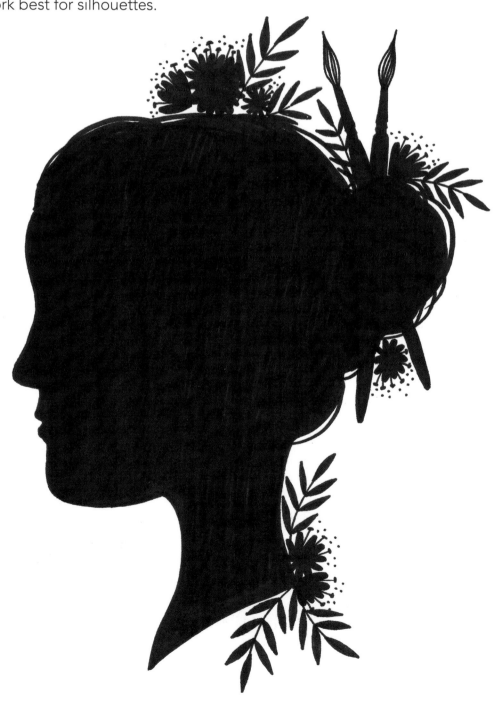

INVENT A FACE OR FIND A REFERENCE PHOTO OF A PERSON'S PROFILE ONLINE, AND TRACE IT TO CREATE A SILHOUETTE.

 PRACTICE HERE!

LOOKING POSITIVELY AT NEGATIVE SPACES

The term "negative space" refers to the space surrounding an object. Looking at the shapes around an object rather than at the object itself will enhance your observational and compositional skills, helping you see traditional shapes in an abstract way.

I like drawing in negative space using pale colors on darker backgrounds plus the cross-hatching technique. Paint markers work best here, as they draw well on dark surfaces.

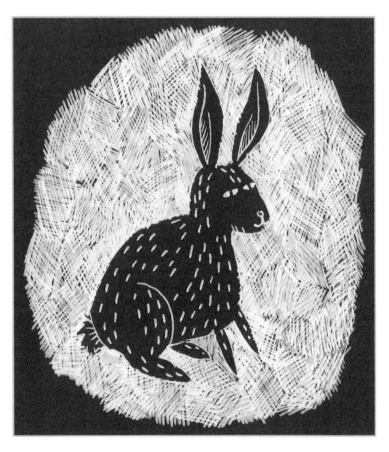

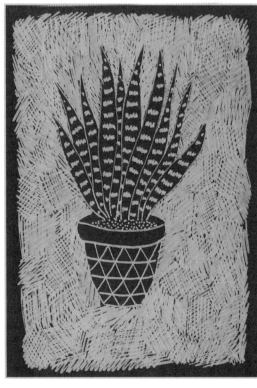

Lightly sketch an object or animal, and crosshatch all around it. Then fill in the details using simple lines and marks.

VARY THE ANGLES OF YOUR CROSSHATCHES TO ADD VARIETY AND INTEREST.

PRACTICE HERE!

DECORATED GLASS FRAME

Glass frames offer a stylish, contemporary alternative to more standard wooden or metal frames, and you can decorate them using paint pens. This kind of frame is ideal for highlighting your favorite black-and-white photograph.

TOOLS & MATERIALS

- Pencil
- Two sheets of glass that are large enough to frame your photograph with a large border
- Sheet of paper
- Black-and-white photograph
- Glue or tape
- Gloss paint markers in black and white (I used a wide and a fineline tip in each color)
- Electrical tape
- Scissors

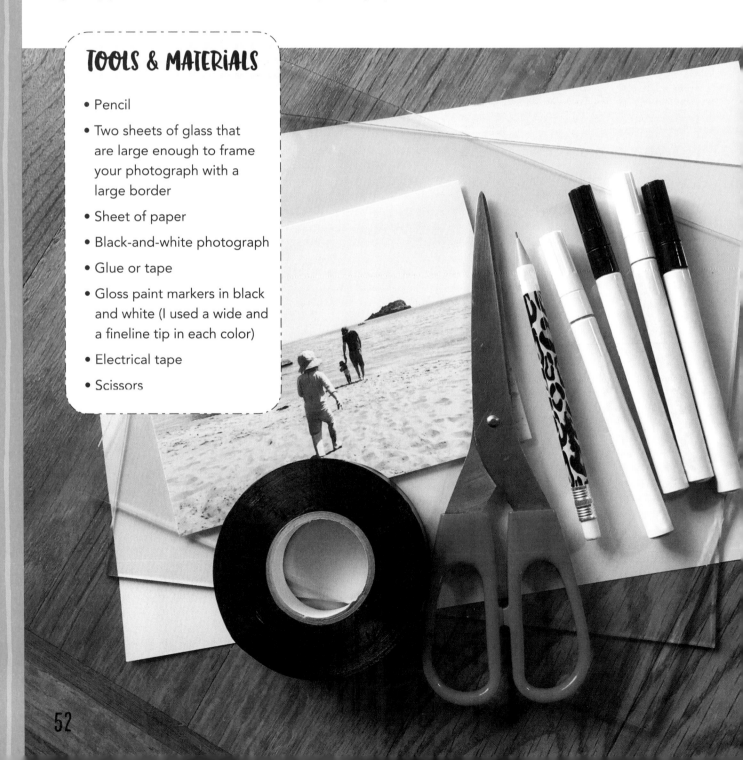

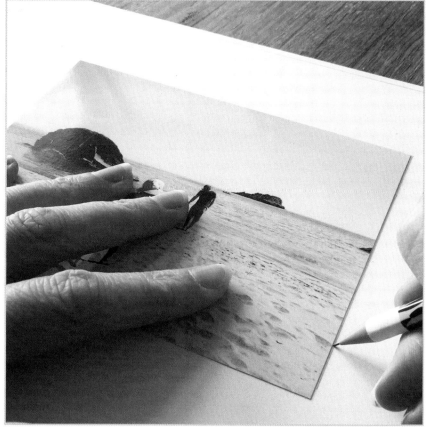

Step 1 Use a pencil to outline a sheet of glass onto a sheet of paper. Place your photo within that outline, and outline the photo as well.

Step 2 Create a simple pencil sketch around the outline of the photo. You may want to go purely decorative using motifs and shapes from nature, or you can incorporate items that you see in the photo.

I made mine nautical to go with the coastal image in the photograph.

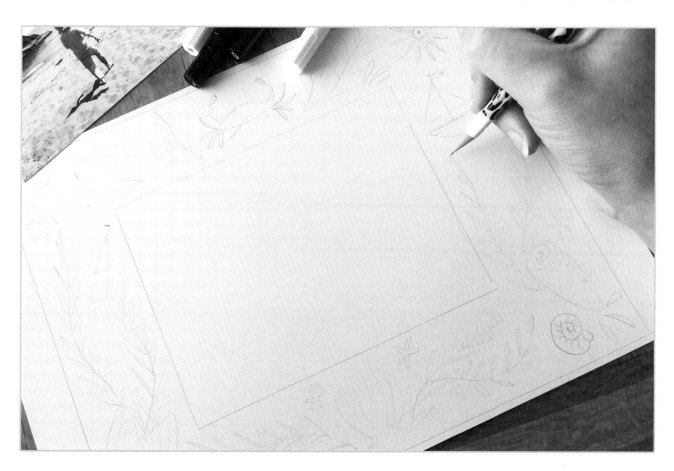

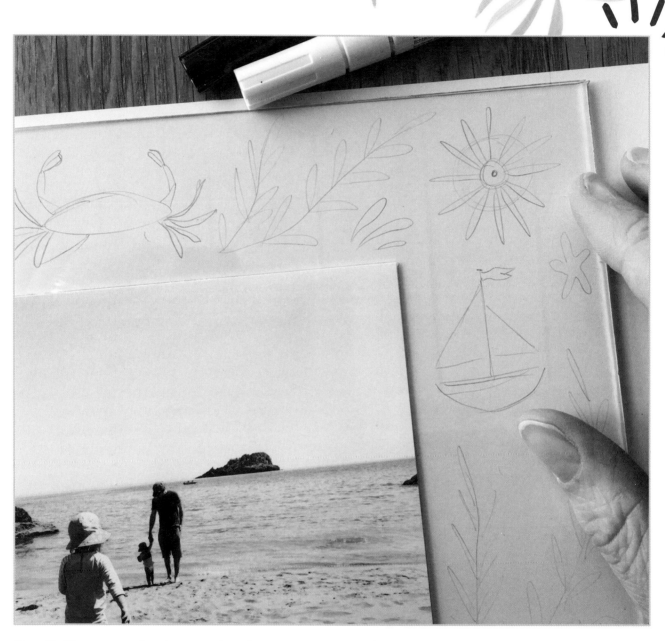

Step 3 Glue or tape the photograph to the center of one of the sheets of glass. Then line up the sketch to frame the photo.

TO AVOID DAMAGING THE PHOTO, APPLY GLUE OR TAPE JUST TO THE CORNERS.

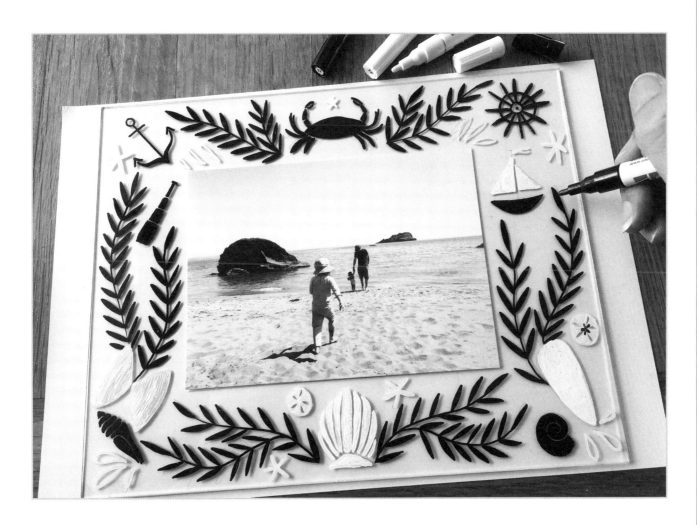

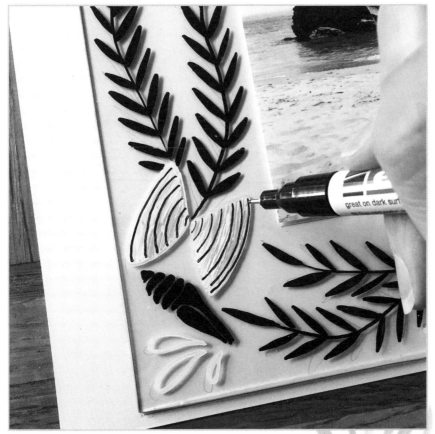

Step 4 Use your sketch as a reference, and draw directly on the sheet of glass. First apply the markers, and then add details on top with fineliner markers once your bottom layer is dry.

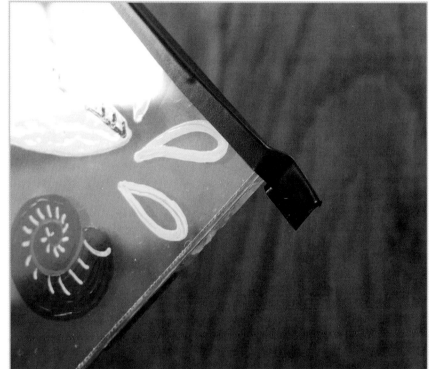

Step 5 Place the second sheet of glass over your completed drawing, and line up the edges. Then use a piece of electrical tape to secure the two sheets of glass together on all sides. Cut off the excess tape, and neaten the corners using scissors or a utility knife.

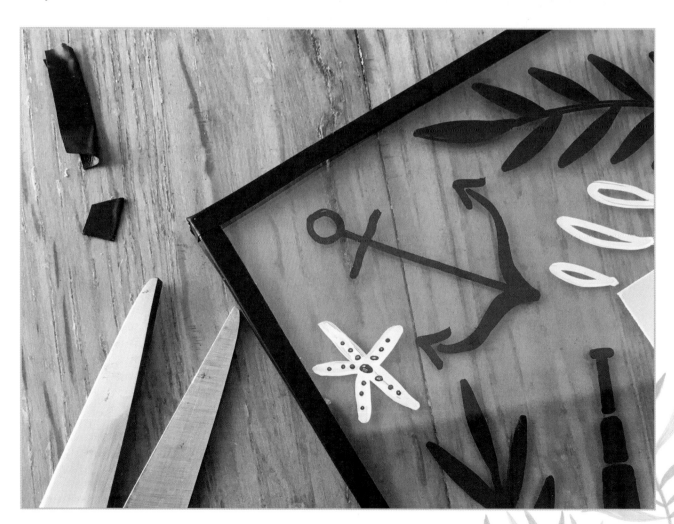

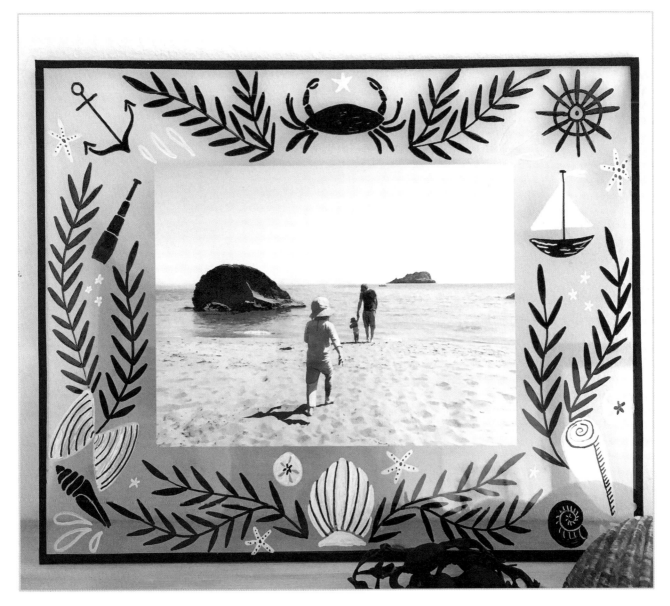

Step 6 Display your hand-drawn frame in your home for a nostalgic, personalized art piece!

THIS FRAME LOOKS GREAT PROPPED UP ON A SHELF OR MANTLE, BUT YOU CAN ALSO USE PLASTIC MIRROR CLIPS FROM A HARDWARE STORE TO ATTACH IT TO A WALL.

A LITTLE BIT OF LETTERING

Hand lettering is a fun way to turn words and letters into works of art. There are many different lettering styles, so play around to find your favorites. Try copying the fonts you see in magazines and newspapers, and create beautiful words of your choice. Hand lettering doesn't have to look perfect!

Different markers can be used to create different effects. Brush pens work well for a calligraphic style, while bullet-tip markers are great for creating precise graphic letters. Try a few different types to discover the ones you like the best.

Piano

Sushi

CAFÉ

CiAO

IF LETTERING SEEMS DAUNTING AT FIRST, REMEMBER THAT IT'S ESSENTIALLY DRAWING—EXCEPT YOU'RE DRAWING WORDS INSTEAD OF THINGS!

ROCK 'N' ROLL panda

PRACTICE HERE!

EMBELLISHED LETTERS

Simple fonts are fun, but adding embellishments to words and letters can really enhance the look of lettering.

Try embellishing a single letter with flourishes, shapes, shadows, and color. Add extra swirls to calligraphic styles or little doodles around the edges. You might draw patterns within block-style lettering or add a shadow using a different color to create depth in your letters.

Using your knowledge of color theory (see pages 10–13), try layering colors, and see what you end up with. Permanent markers don't smudge or bleed, which makes them great for layering colors.

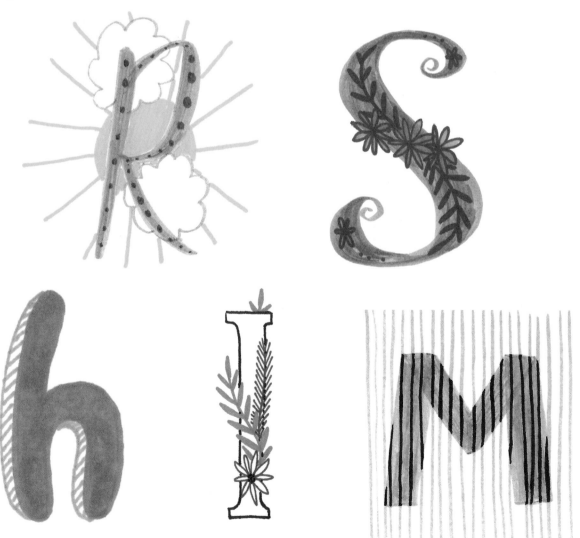

 PRACTICE HERE!

PERSONALIZED JOURNAL COVER

Whether you're an artist, a student, or a working professional, a notebook or journal can help you stay organized. It's also a great place to doodle and brainstorm creative new ideas.

A journal with a personalized cover created by you makes a great gift as well. Here you'll learn how to make your own little work of art using a journal cover.

TOOLS & MATERIALS

- Pencil
- Scratch paper
- Permanent markers with different nib widths and in different colors, including white
- Tracing paper
- A journal with a cover you can draw on

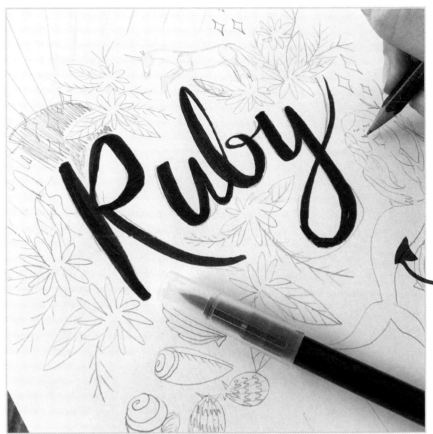

Step 1 Think about the person for whom you're creating this journal. How do you want to write his or her name, and what is this person interested in?

Sketch your ideas on a sheet of scratch paper. Try embellishing the person's name with flourishes and details from his or her hobbies.

Step 2 Now think about where you might want to add color and further details. I like to use a limited color palette, so I've chosen pink and black to add contrast to the journal's cover. When I'm almost finished, I'll use a white marker to add highlights.

Step 3 If you're confident about your drawing skills, go ahead and copy your hand-lettered art directly onto the journal cover using a pencil.

Or, on a sheet of tracing paper, trace over your sketch with a pencil. Then turn over the tracing paper, and draw over the sketch again on the back side. By turning the tracing paper right-side up again and pressing on it using a bone folder or a pencil, you will create a faint print on the journal cover. Use this as a guide.

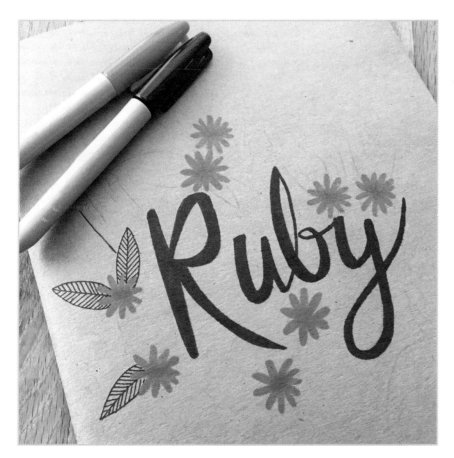

Step 4 When you're ready to add color, start with the name. Work outward from there, adding any larger design elements. Use markers of different thicknesses to create a variety of lines.

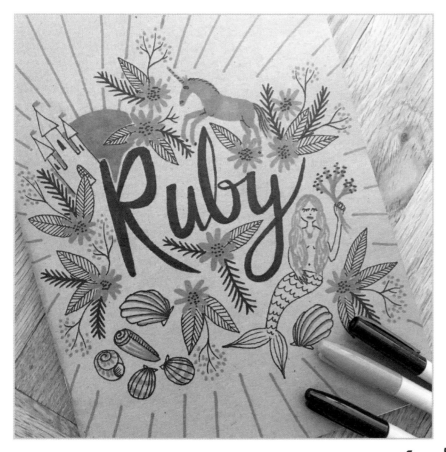

Step 5 Once you have the larger parts of the design in place, add your details. Your hand-lettered art will really start to come together now!

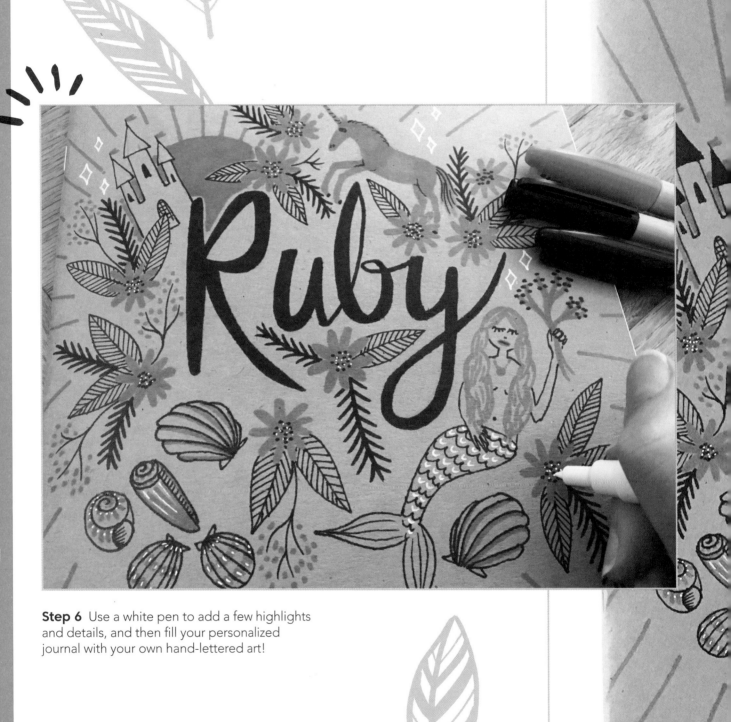

Step 6 Use a white pen to add a few highlights and details, and then fill your personalized journal with your own hand-lettered art!

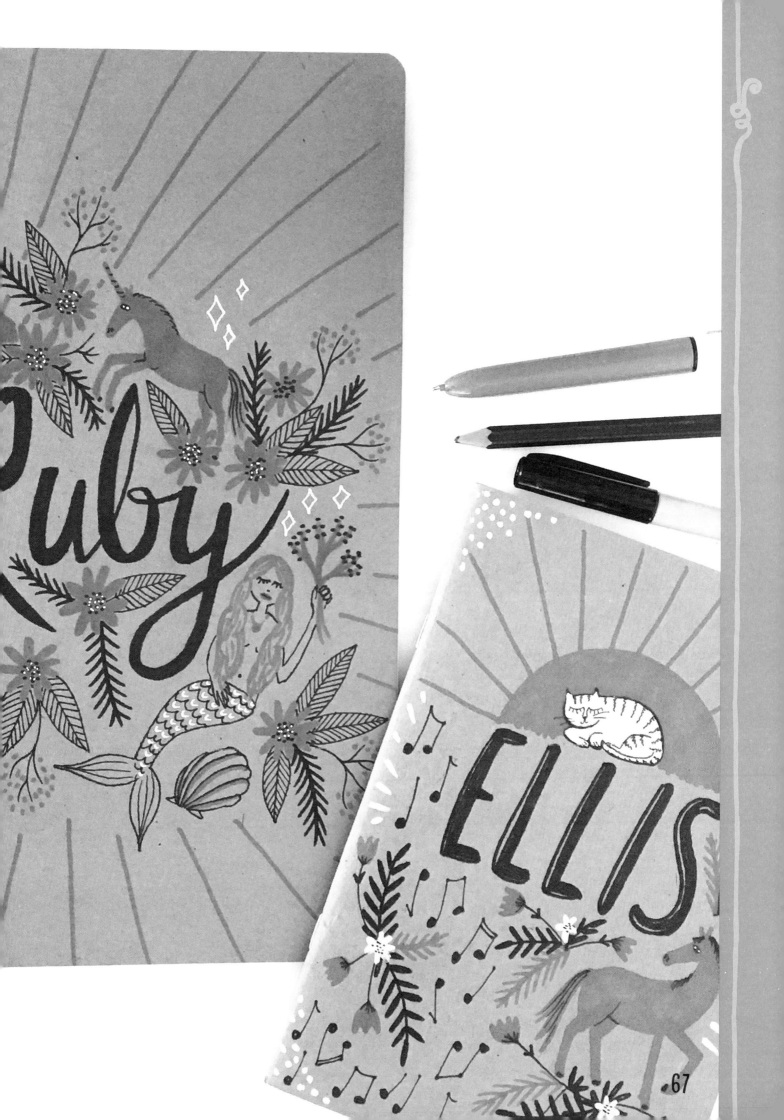

COLOR INSPIRATION

At first, the limited palettes that some types of markers come in can seem like a hindrance. Don't lose heart, though; having fewer colors to choose from can make you *more* creative!

Select a photo with a pleasing color palette, and grab four or five markers that match the colors in the photo. Try layering them to create additional colors.

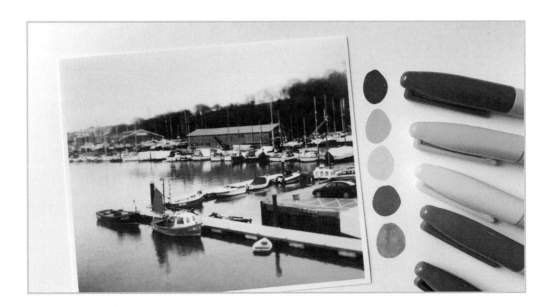

FH 740

 PRACTICE HERE!

BACK TO BASIC BLOOMS

You can draw realistic-looking flowers using markers, but you might find the color selection a bit restrictive.

When drawing flowers, I like to embrace the graphic nature of my pens and go simple.

Search online to find a picture of a flower. The possibilities are endless! Study the flower and color-match your markers, just like you did on pages 30–31. Then draw the flower, paying close attention to its petals' shapes and details.

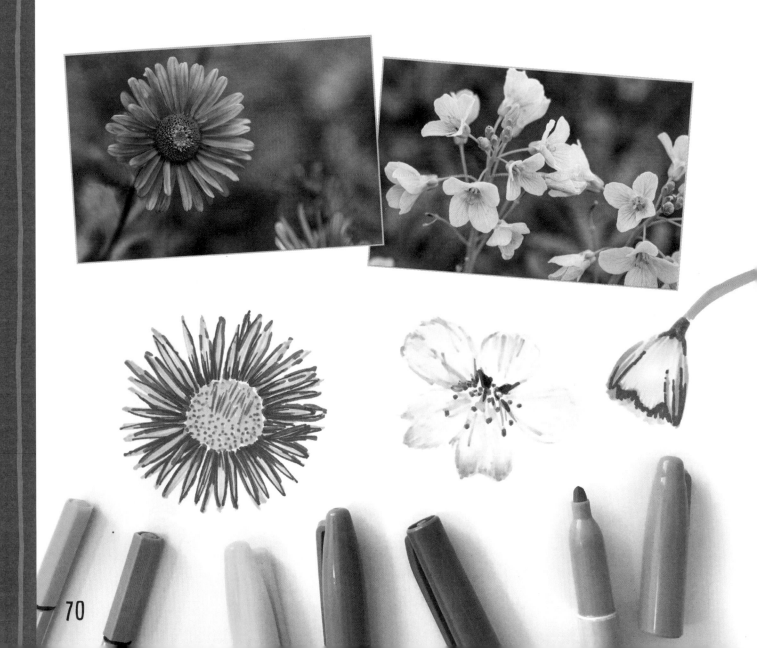

Choose a few of your favorite colors from your drawing of a flower, and see how much you can simplify it while retaining the same overall look.

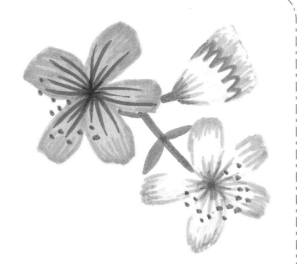

🐾 PRACTICE HERE!

MIRRORING MARKER ART

Drawing directly on a mirror using a limited color palette creates a beautiful, eye-catching, and useful piece of art. You'll need to use permanent paint markers to make marks on a mirror's smooth, shiny surface. Choose water- and abrasion-resistant paint markers, and your mirror will last the test of time ... and the many admiring looks cast its way!

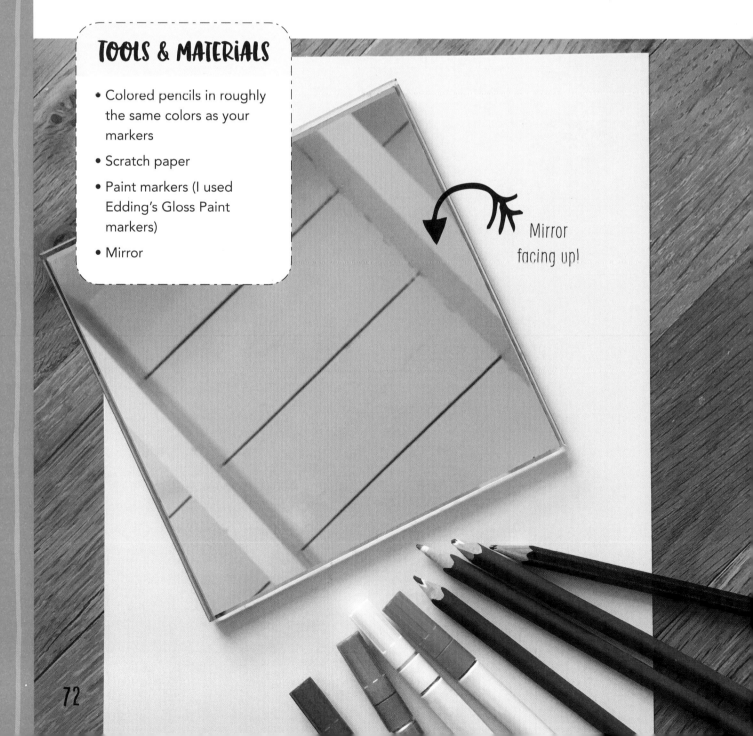

TOOLS & MATERIALS

- Colored pencils in roughly the same colors as your markers
- Scratch paper
- Paint markers (I used Edding's Gloss Paint markers)
- Mirror

Mirror facing up!

Step 1 Use colored pencils to sketch out your design. Do you want to fill the mirror, or would you like to create just a decorative border? Which colors do you plan to use?

I chose a limited color palette and decided to add highlights once I finished the main part of my design.

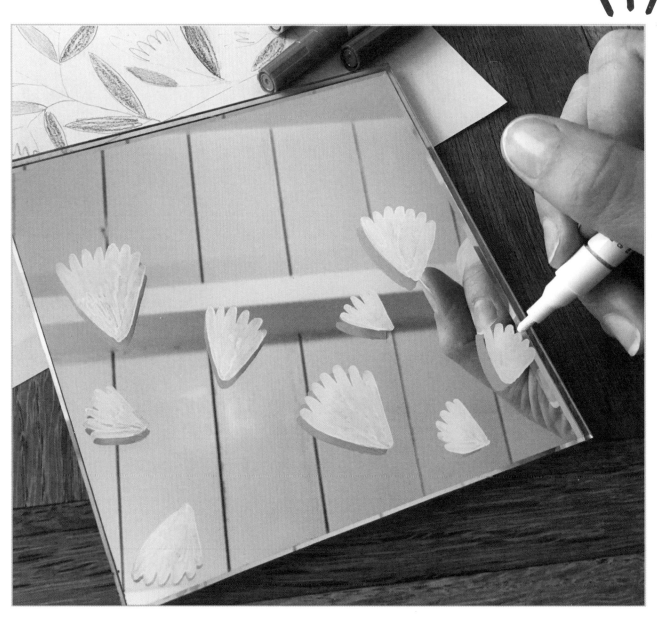

Step 2 Grab your paint markers and the mirror, and refer to your sketch before adding the flowers' main elements. Paint markers are great for layering, so there's no need to add light colors first. Add colors in any order you like.

YOU'LL WANT TO WORK QUICKLY WHEN DRAWING WITH PAINT MARKERS, AS THEY DON'T BLEND WELL ONCE DRY. SIMILARLY, MAKE SURE THE PAINT IS DRY BEFORE GOING OVER IT WITH ANOTHER COLOR.

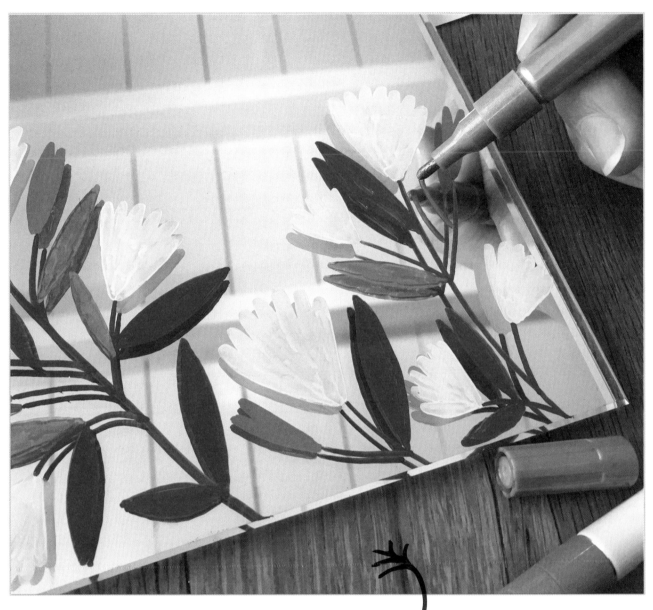

Step 3 Add the stems and then the leaves.

Now take a close look at your composition. Is it different from your original composition? If so, you might want to add some extra flowers or leaves to balance it out.

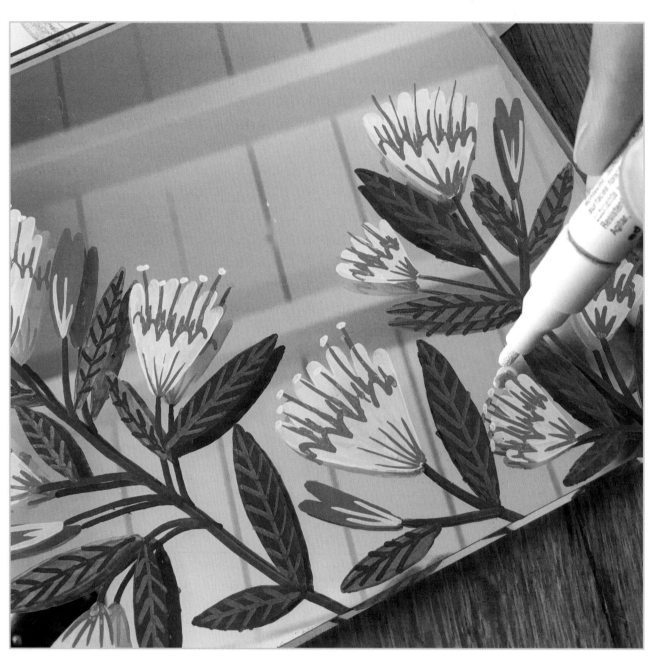

Step 4 Once the base layer is completely dry, add a secondary color to the flowers.

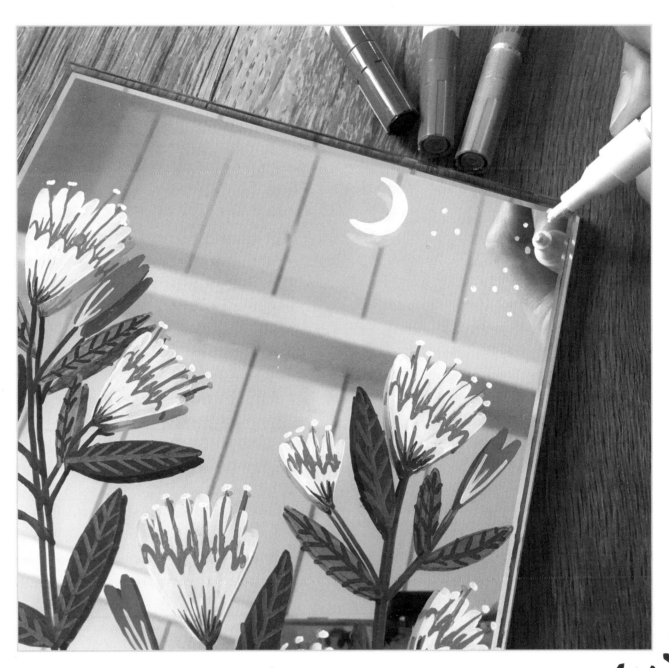

Step 5 Now add details to your drawing to finish it up. Try adding veins to the leaves, petals and stamens on the flowers, and embellishments like stars, dots, and small leaf and petal shapes. Anything goes!

PHOTOGRAPH YOUR FINISHED HAND-DRAWN MIRROR, AND SHOW IT OFF ON YOUR SOCIAL MEDIA! ANGLE THE MIRROR WHEN PHOTOGRAPHING IT SO THAT YOUR REFLECTION DOESN'T SHOW UP IN THE PHOTO.

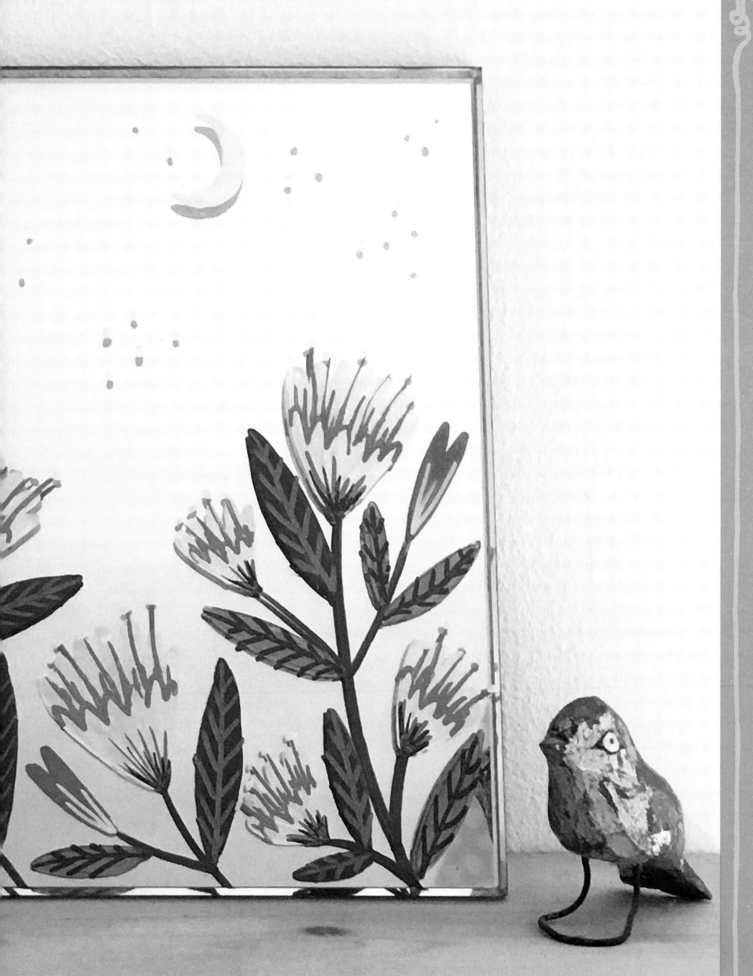

DRAW ANYTHING!

Sometimes when you sit down to make art, you grab your markers and a clean sheet of paper, try to draw, and … oh no! You can't think of anything to draw!

Fortunately, inspiration can be found in even the most mundane places. Do you have a favorite object in your home? Using your favorite markers, draw it in lots of different ways. Here is an idea to help you get started!

I DECIDED TO DRAW MY FAVORITE SHELL WITH A BIT OF DRIED SEAWEED STUCK TO IT. IT'S UNUSUAL AND NATURAL, WHICH IS WHY I LIKE IT!

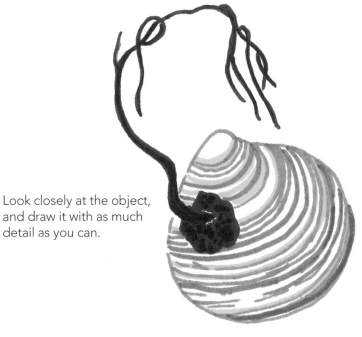

Look closely at the object, and draw it with as much detail as you can.

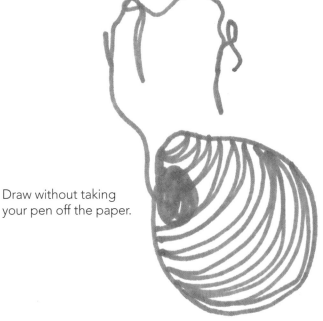

Draw without taking your pen off the paper.

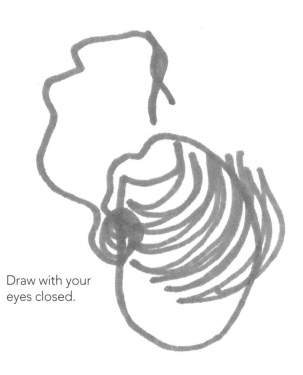

Draw with your eyes closed.

Draw the object from memory.

Use a single, solid line to draw the object.

Draw as quickly as you can.

Use your nondominant hand.

 PRACTICE HERE!

PATTERNS & ICONS

I love drawing patterns, and one of my favorite ways to do that is by creating icons. This simply means drawing lots of items with a theme in mind and then combining them to create a pattern.

What's your favorite hobby? Think of the many things you can do with that hobby, no matter how insignificant or cliché they might seem. Draw those items! Then scan the drawings onto your computer, and create a pattern.

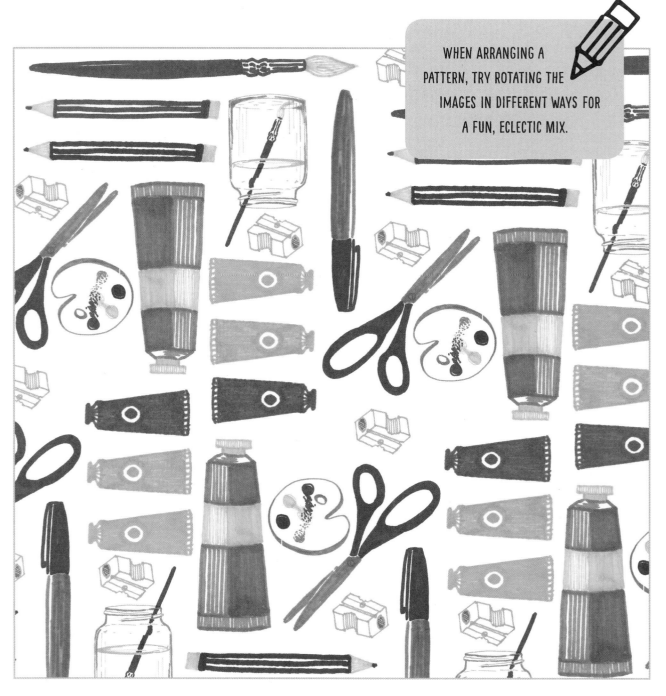

WHEN ARRANGING A PATTERN, TRY ROTATING THE IMAGES IN DIFFERENT WAYS FOR A FUN, ECLECTIC MIX.

PRACTICE HERE!

CULINARY WALL ART

You can combine icons into a single piece of wall art to capture the essence of your favorite hobby or room in your home. Wood, with all of its knots and grains, makes a plain-but-interesting background to work on that's perfect for patterns. Look for a suitable piece of wood at hardware and do-it-yourself stores.

TOOLS & MATERIALS

- Black marker
- Sheets of scratch paper
- Pencil
- Piece of wood (I used a bamboo cutting board)
- Permanent markers in three pairs of matching colors (I used two shades each of orange, green, and blue)
- White paint marker

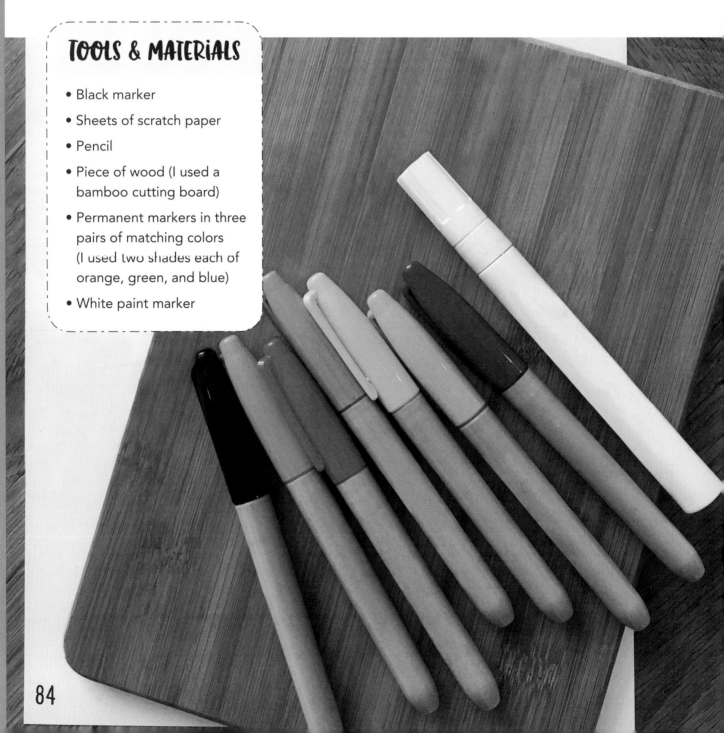

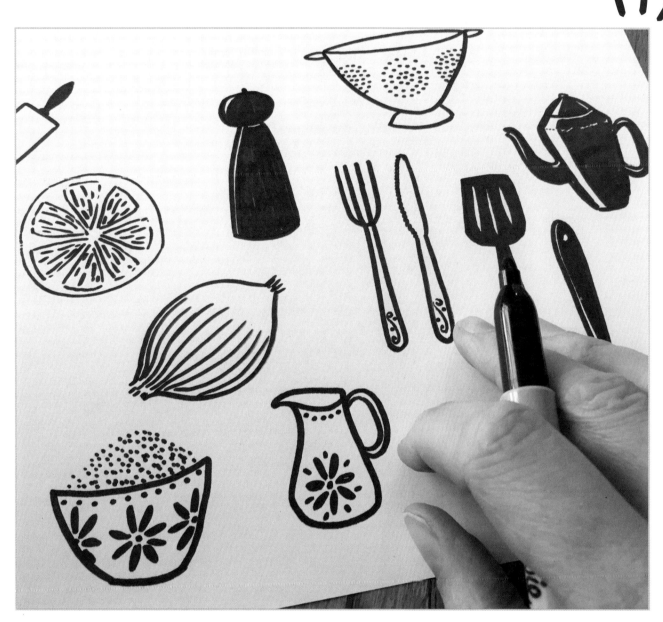

Step 1 Prep your piece by drawing kitchen-themed icons on a sheet of scratch paper. Kitchens feature so many lovely shapes, including cutlery, jars, pots, and pans, as well as food items. Draw your favorites!

I started simply and used just a black permanent marker to draw.

Step 2 Trace the piece of wood onto a sheet of scratch paper. Inside the outline, make rough pencil sketches of your icons. Arrange them in oval and circular shapes.

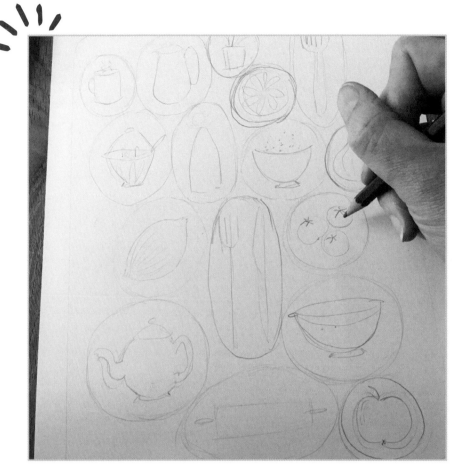

Step 3 Select your colors. You will use some for backgrounds and others for the icons.

LOOK AT YOUR SKETCH FROM A DISTANCE TO CHECK YOUR COLOR COMPOSITION. GETTING A DIFFERENT PERSPECTIVE CAN TOTALLY CHANGE HOW YOU VIEW SOMETHING!

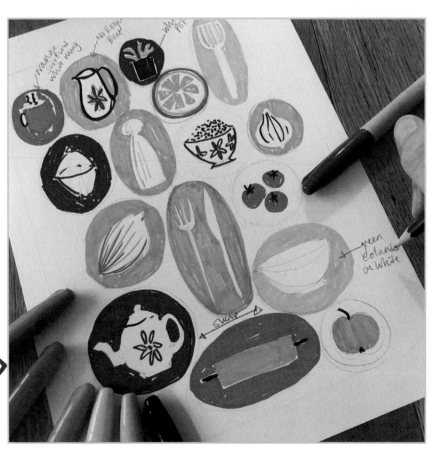

BEFORE DRAWING ON THE PIECE OF WOOD, TEST YOUR MARKERS ON THE BACK. SOME MARKERS WILL RUN INTO THE WOOD GRAIN. IF THIS HAPPENS, YOU CAN LIGHTLY SPRAY THE PIECE OF WOOD WITH MATTE VARNISH BEFORE YOU BEGIN.

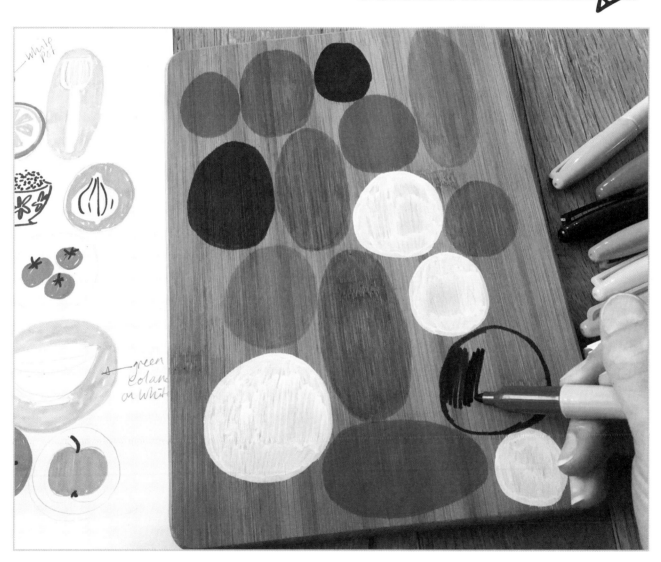

Step 4 Using your sketch as a guide, draw the background shapes onto the piece of wood.

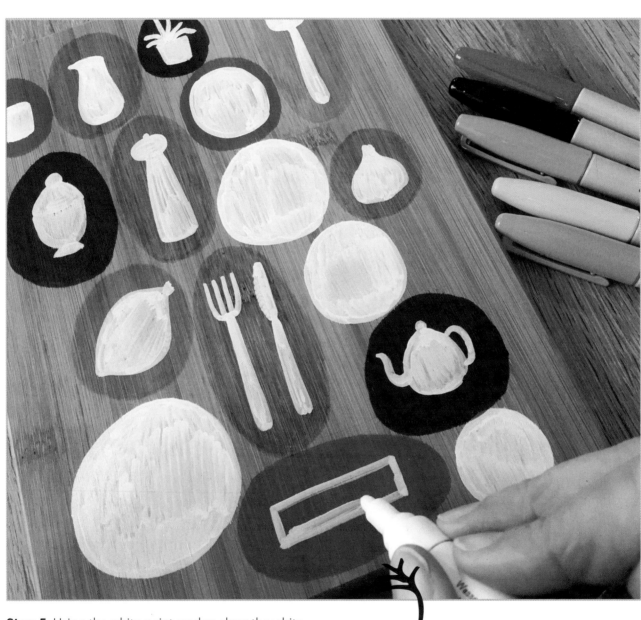

Step 5 Using the white paint marker, draw the white portions of your icons and any areas that need to be lighter than the background color. You can color over the white later.

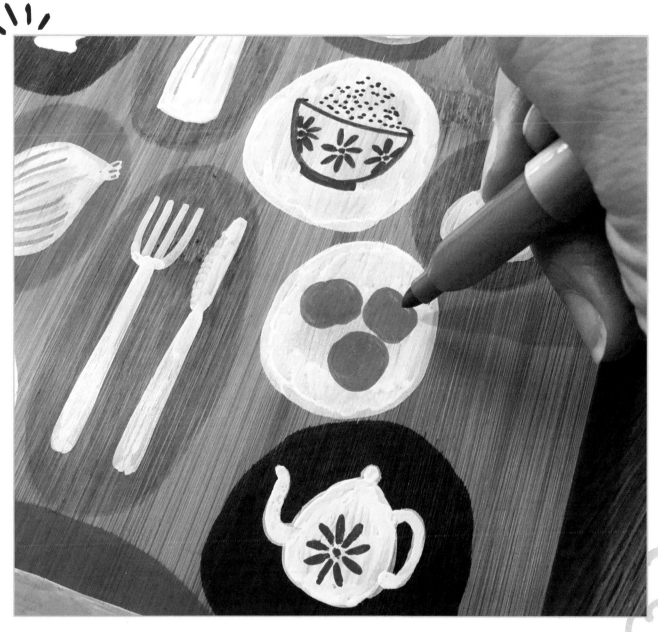

Step 6 Add color to your icons.

Step 7 Add details in black.

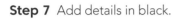
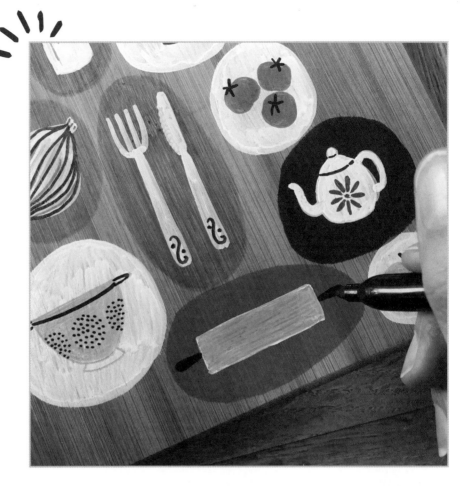

Step 8 Take a step back, and look at your composition. Add decorative details, such as simple floral shapes, to tie the artwork together with the theme and finish up your culinary masterpiece.

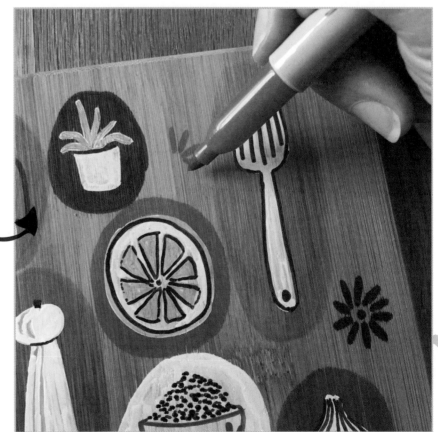

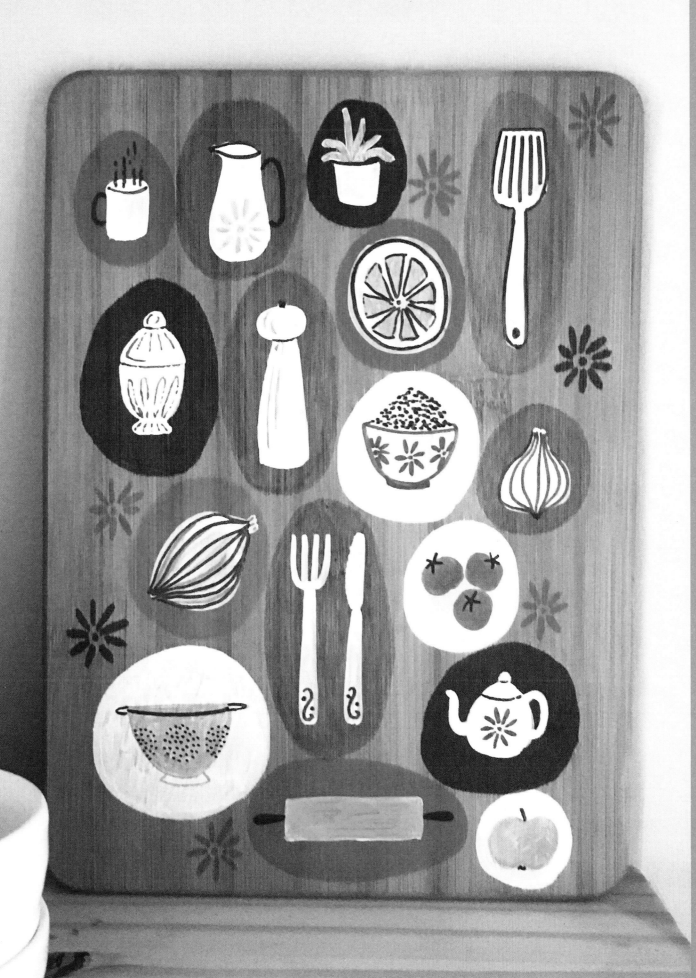

PATTERNED WINGS

Loose, hand-drawn patterns are fun to draw, but figuring out how to get started can be the most difficult part of the process.

Birds' wings are one of my favorite sources of inspiration. Drawing feathers gives you the opportunity to try lots of different mark-making techniques, and you also get to create a sweet bird at the same time!

Start by drawing feathery shapes. Draw some feathers realistically, and make others more stylized. Draw neatly at first, and then try a really loose drawing style.

When you have a few different feather styles in your armory, you can use my templates (see page 93), or sketch your own birds with a pencil. Then fill in the details with markers.

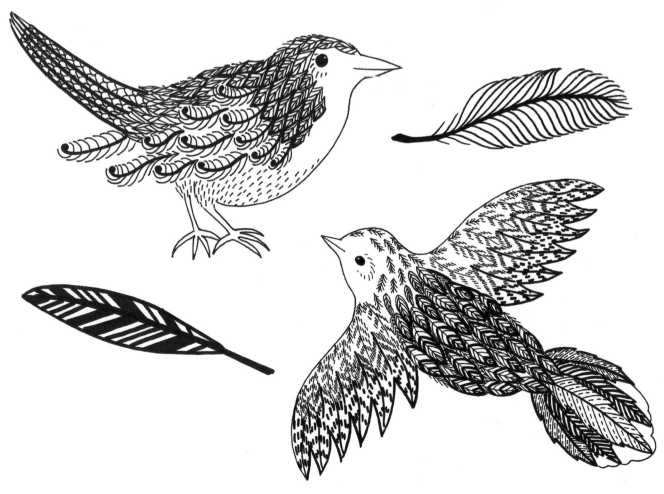

Draw birds with simple shapes, round heads, or oval bodies.
Try drawing birds in flight and with their wings folded!

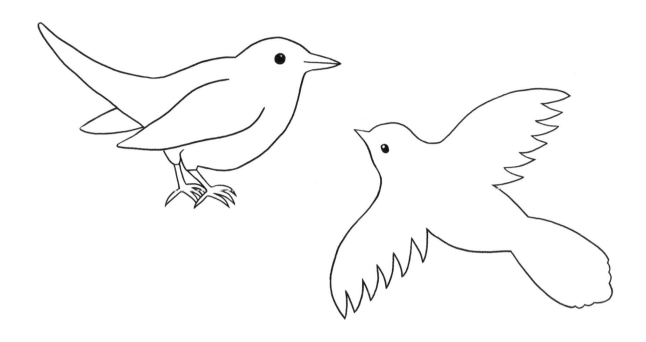

🐦 PRACTICE HERE!

METALLIC FEATHERS

When drawn on a dark background, metallic patterns create striking artwork.

Using the feathery marks and patterns you already created on page 93, metallic markers, and sheets of paper in dark colors, draw random feathery shapes.

First draw one motif scattered across the paper, and then fill in the gaps with different shapes to create a densely patterned piece. Vary how you use the markers. Fill in some areas, and draw only fine lines in others to create contrast and random patterns.

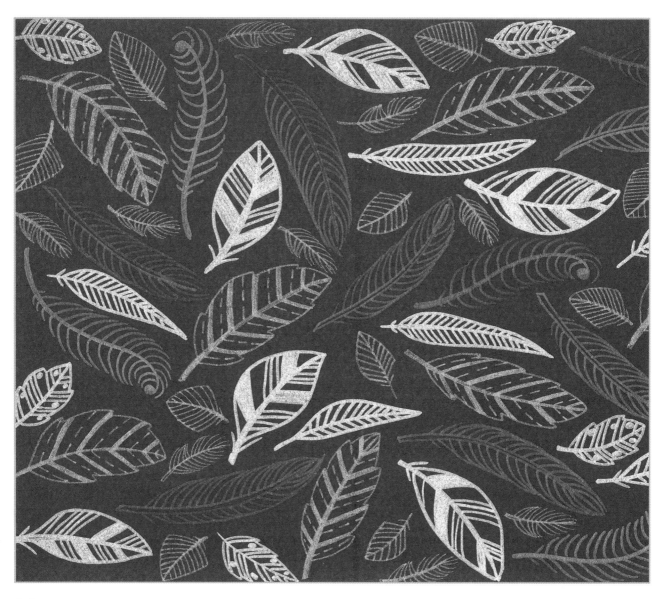

USE THE SAME TECHNIQUE TO
DRAW LEAVES AND FLORALS!

 PRACTICE HERE!

QUOTABLE ART

Hand-lettered art featuring an inspirational quote makes for a beautiful wall hanging, and if the quote inspires viewers, that's even better. Think of it as a pep talk every time you pass your handcrafted artwork!

TOOLS & MATERIALS

- Sheets of scratch paper
- Pencil
- Tracing paper
- Sheet of dark blue paper
- Gold and silver markers

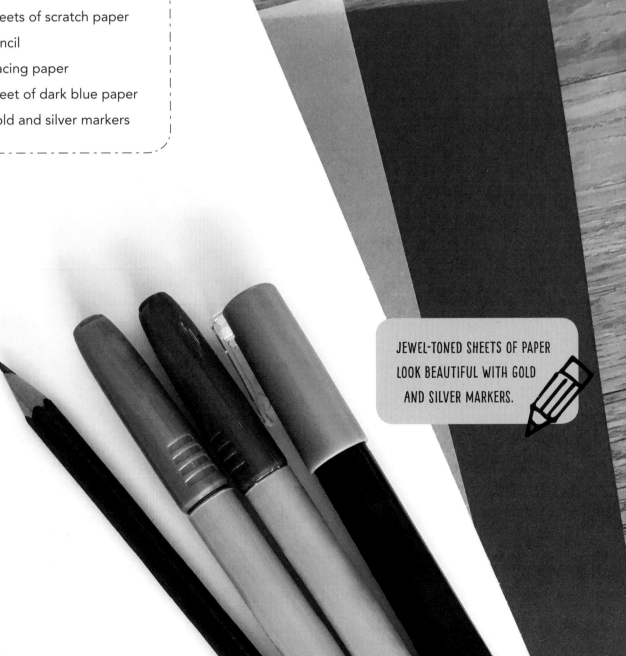

JEWEL-TONED SHEETS OF PAPER LOOK BEAUTIFUL WITH GOLD AND SILVER MARKERS.

Step 1 Do a bit of research, and find a quote that means something to you. Maybe you'd like a little motivation or a motto for your everyday routine?

Using various lettering styles, do some thumbnail-sized sketches of the quote you've chosen, and see which lettering style best suits the piece you want to create. Try laying out the quote in different ways.

Step 2 Once you've designed a layout that you like, create a more finalized sketch in the size that you want your final artwork to be. Take your time; you want your quote to be legible as well as artistic, and it can take some practice to increase a sketch from thumbnail to full-size.

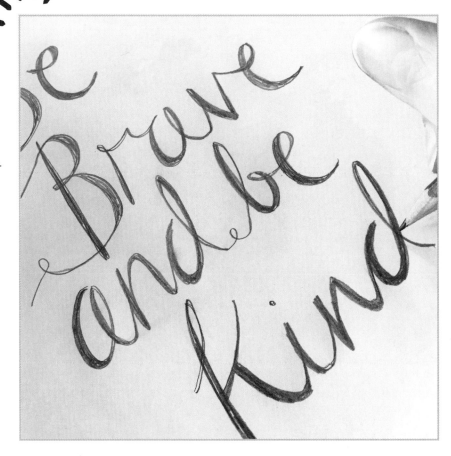

Step 3 Create a border around the letters in your sketch. You want the words to stand out, so keep the border fairly simple and decorative. I drew shapes inspired by nature, including a simple bird, and then added stars and a moon for a little touch of magic!

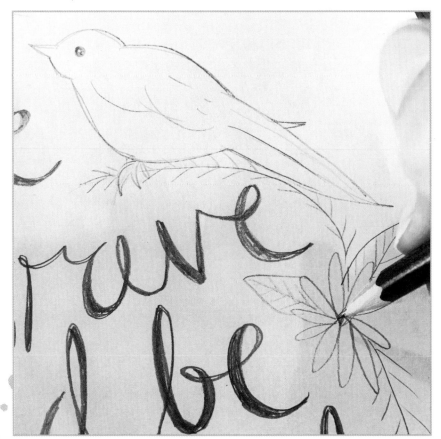

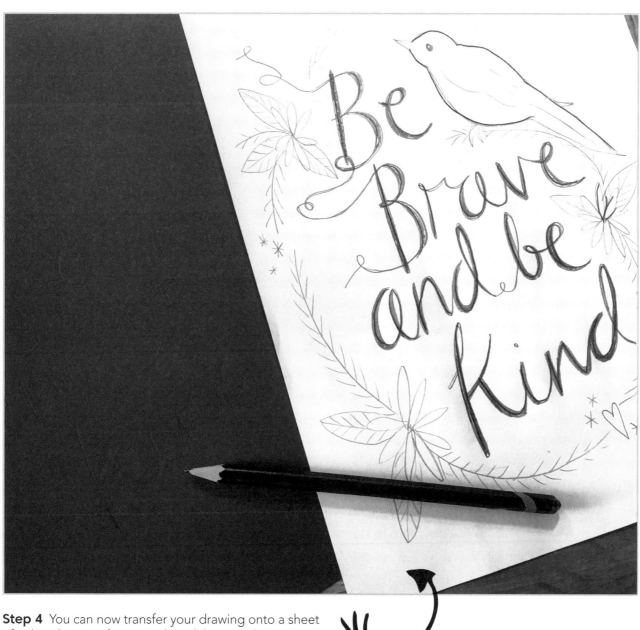

Step 4 You can now transfer your drawing onto a sheet of colored paper. If you need guidelines, make some light sketches, or use tracing paper. (For a refresher on using tracing paper, see page 64.)

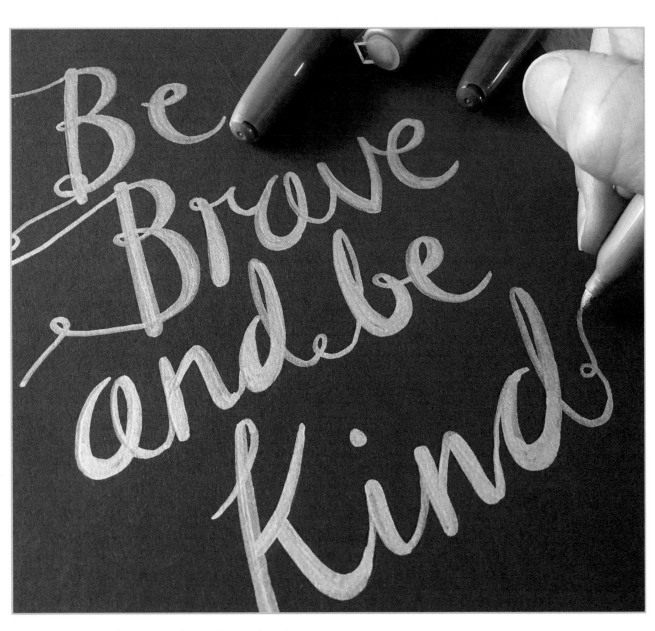

Step 5 Use one of your metallic markers to hand letter the quote.

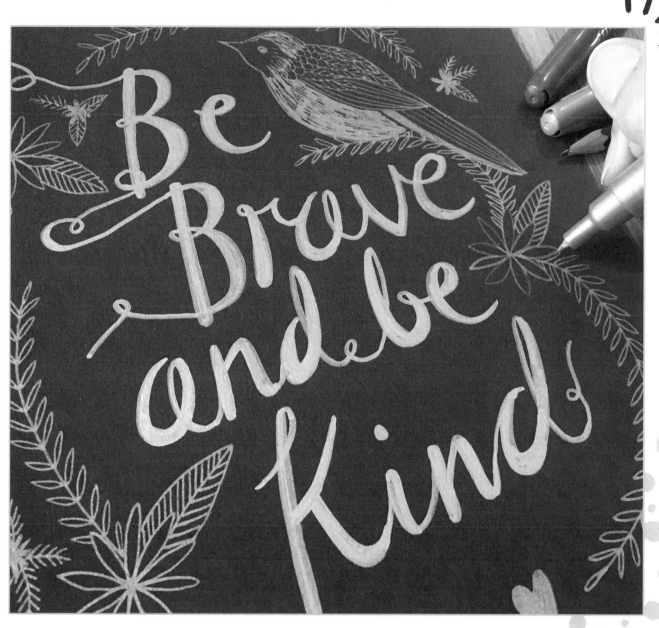

Step 6 Add the decorative border using the other metallic marker. Skip some of the finer details, such as the stars and floral elements.

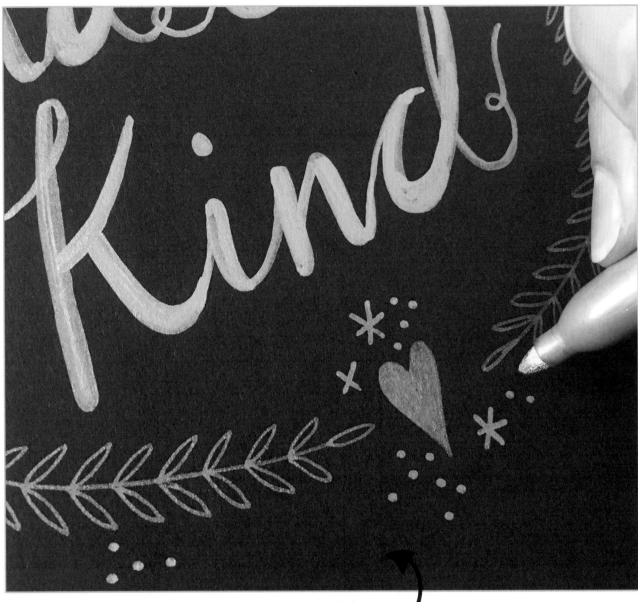

Step 7 Using the same marker that you used to hand letter the quote, add the final details to delicately tie in the color of the quote with the border.

Step 8 Frame your art piece, and feel inspired every day!

Be
Brave
and be
Kind

MAKING MARKERS PRETTY

Markers aren't always associated with "soft" pictures. Their colors are bold and graphic, and they produce lines with hard edges. Brush markers can be used to create softer lines, but how do you do that with a permanent marker? The answer lies in using an often-rejected kind of marker: one that's starting to run out of ink!

When a marker begins to dry out, don't throw it away! Use it to add colors and layers and to soften your images. Drying-out markers are also great for creating pale areas, textures, and shading.

Here are some fun ways to make use of your drying-out markers.

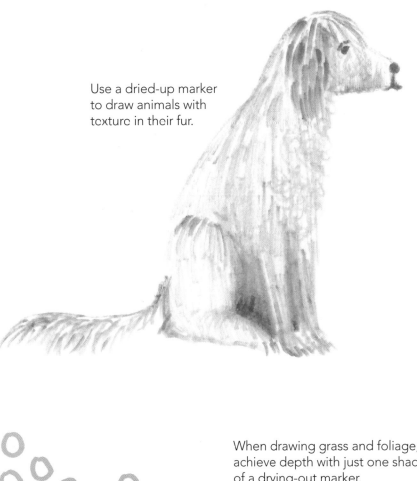

Use a dried-up marker to draw animals with texture in their fur.

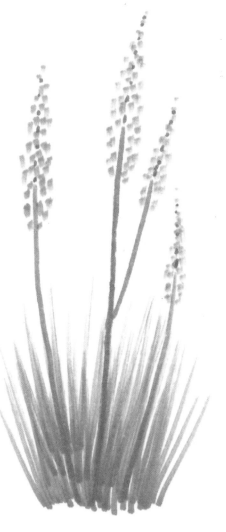

When drawing grass and foliage, achieve depth with just one shade of a drying-out marker.

Add shading just as you would with a pencil. Use a light touch with your marker, and add layers on top using other drying-out colors.

IF THE INK STOPS FLOWING, TRY REPLACING THE CAP ON YOUR DRYING-OUT MARKER. LEAVE IT ON FOR A FEW MINUTES TO GIVE YOUR MARKER A NEW LEASE ON LIFE ... AT LEAST FOR A LITTLE WHILE!

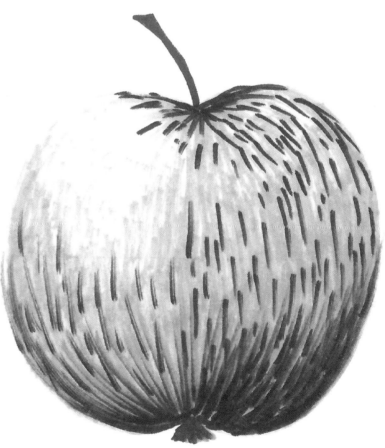

Draw cats using a marker that's running low on ink.

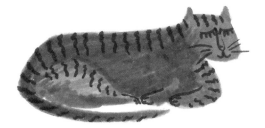

 PRACTICE HERE!

Try drawing a garden using just a couple of colors and a drying-out marker.

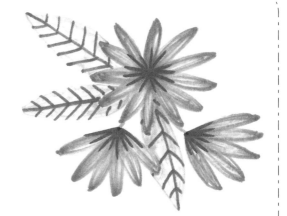

 PRACTICE HERE!

DRAWING WITH A SINGLE COLOR

Sometimes, the most striking images consist of just one color. Introducing an old marker to a drawing that also features brand-new markers can add depth and texture to your art.

Consider where you want to place any softer, more sensitive-looking areas. Draw these with dried-out markers, and then use a fresh marker and a fineliner in the same color to layer details on top.

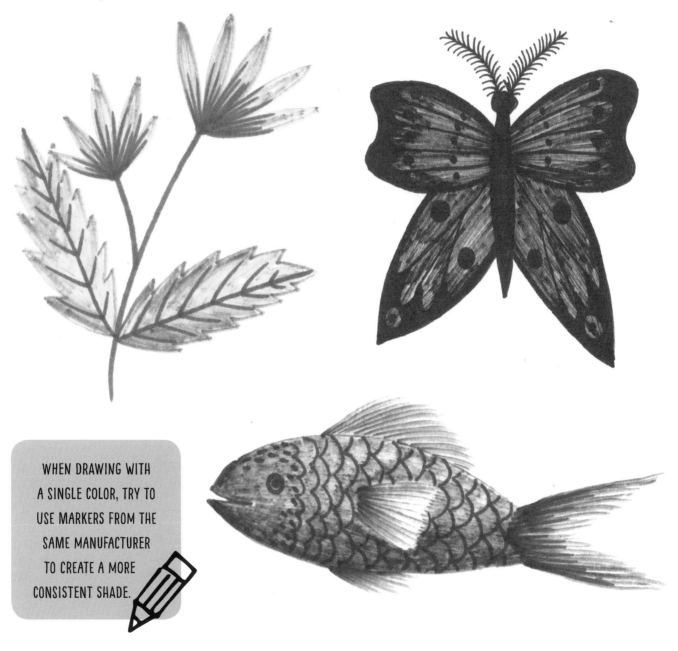

WHEN DRAWING WITH A SINGLE COLOR, TRY TO USE MARKERS FROM THE SAME MANUFACTURER TO CREATE A MORE CONSISTENT SHADE.

Try drawing the soft, fluttering wings of a butterfly; delicate petals on
a flower; or shimmering scales and feathery fins of a fish.

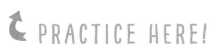 PRACTICE HERE!

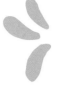

MONOGRAMMED WALL HANGING

A monogrammed wall hanging makes the perfect gift for the proud parents of a bouncing newborn! Give them something special and personalized that you've created yourself.

TOOLS & MATERIALS

- Pencil

- Paper

- Primed fabric in the banner shape of your choice

- A wooden dowel that's about two inches longer than the width of your banner

- A needle and embroidery thread in a color that suits your drawing

- A selection of permanent markers (use new and/or drying-out ones)

- Colorful twine that's about one-and-a-half times longer than the dowel

- Scissors

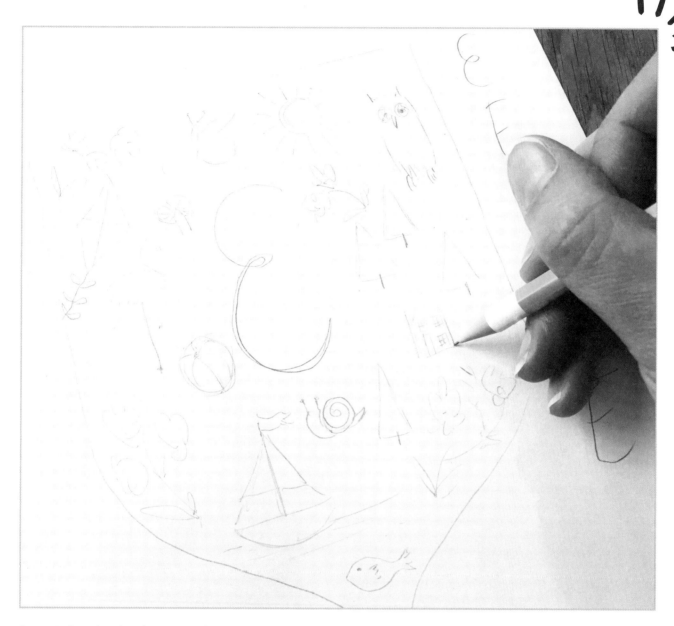

Step 1 Start by sketching your design onto a sheet of paper.

I've chosen to create a banner that features a central monogrammed letter "E" for the baby's name as well as cute, baby-related imagery.

HAVE THE NEW PARENTS CHOSEN A THEME OR COLOR SCHEME FOR THEIR NURSERY? CONSIDER THEIR INTERESTS, LIKES, AND DISLIKES!

Step 2 Grab your banner, and place the dowel at the top. Roll the banner over the dowel, leaving a half-inch strip of fabric below the dowel.

Use the needle and your embroidery thread to sew a line along the extra fabric and create a loop for the dowel to sit inside.

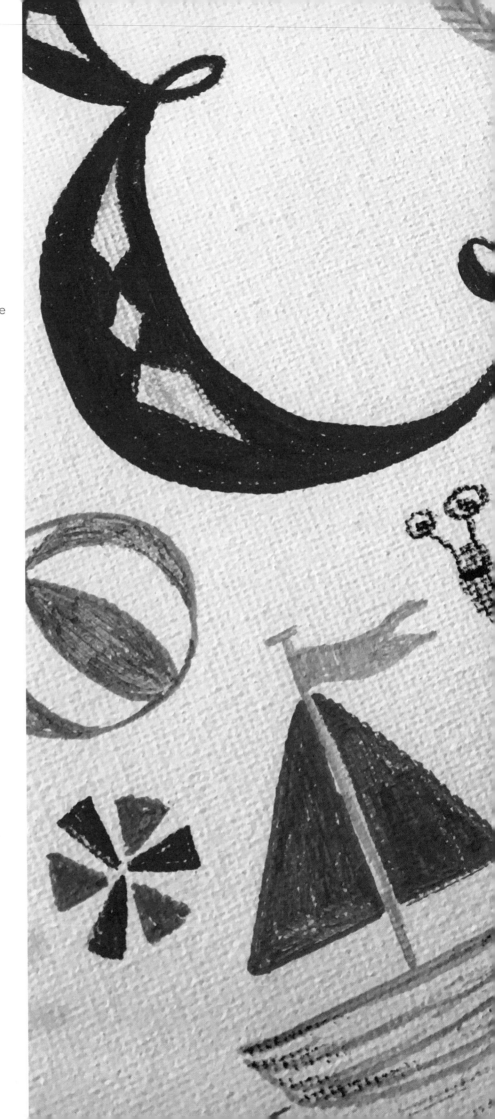

Step 3 Using your sketch as a guide, draw the monogram in the center of the banner. Then add your drawings around it. Make sure to include lots of little elements and stripes around the sides to define the edges of the banner!

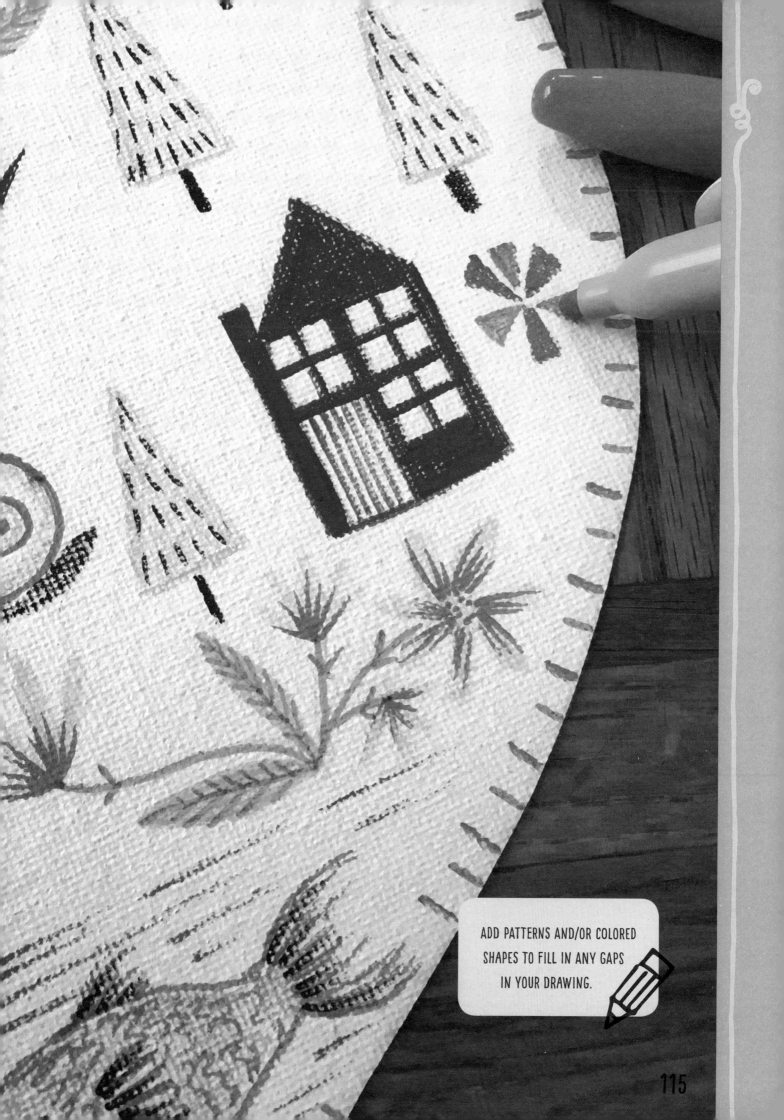

ADD PATTERNS AND/OR COLORED
SHAPES TO FILL IN ANY GAPS
IN YOUR DRAWING.

Step 4 Tie one end of the twine to one end of the dowel. Secure the other end of the twine to create a hanger for the banner.

WRITE A MESSAGE TO THE NEWBORN BABY ON THE BACK OF THE BANNER!

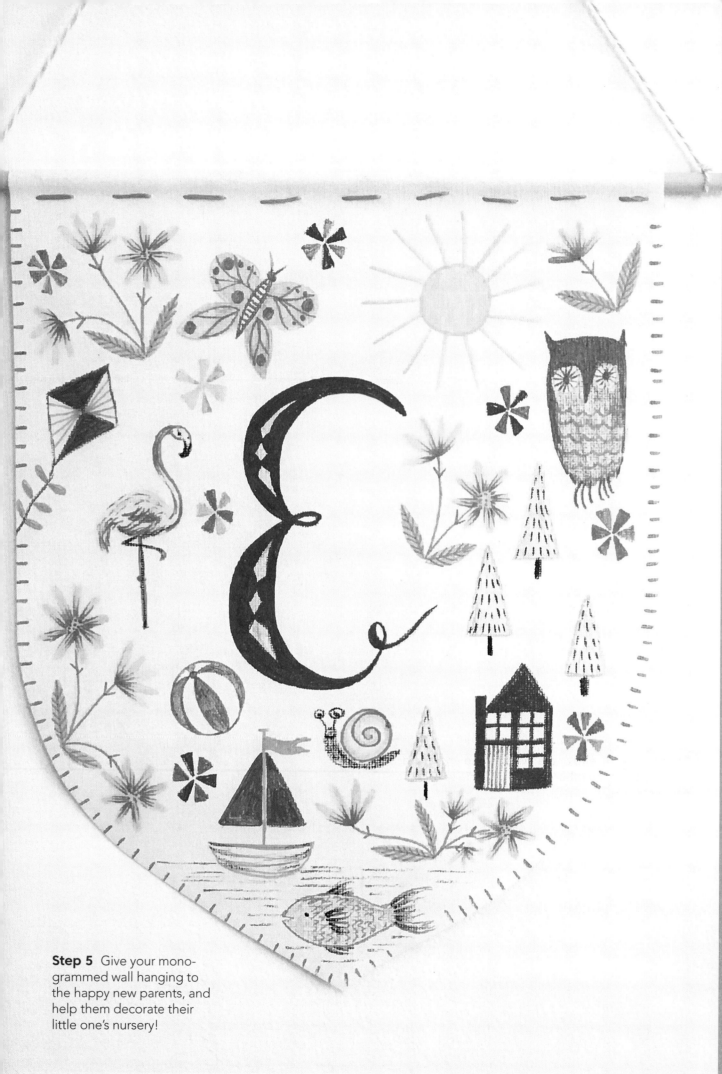

Step 5 Give your monogrammed wall hanging to the happy new parents, and help them decorate their little one's nursery!

WATERCOLOR EFFECTS

Markers may be meant for making standard marks, but that doesn't mean you can't create some pretty great effects by adding other materials to your drawings as well. The color in permanent markers is meant to be permanent, but adding a little bit of rubbing alcohol can turn your drawings into beautiful watercolors.

Make sure you work on watercolor paper or fabric to keep the surface from buckling. You will find that each surface produces different effects. For example, working on fabric will help your colors spread more easily, while watercolor paper will require you to keep your marks closer together and move the rubbing alcohol around using a small paintbrush. Play around with both surfaces, and see which one works best for you.

You will need permanent markers and a pipette to drop the rubbing alcohol onto your marks. If you work on fabric, an embroidery hoop will come in handy to secure your fabric and pull it tight.

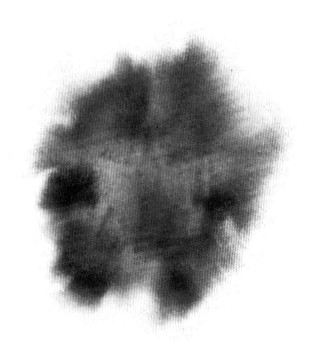

MAKE SURE YOU WORK IN A WELL-VENTILATED AREA!

Start by drawing a simple shape or pattern, and then drop a little rubbing alcohol on it, and see what happens!

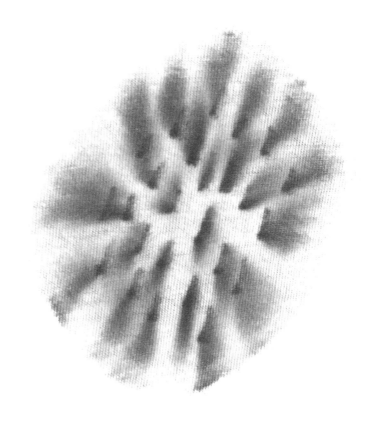

Draw marks and circles around a central point, drop rubbing alcohol in the middle, and watch the color spread from the center.

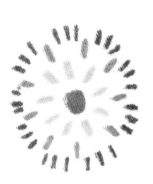

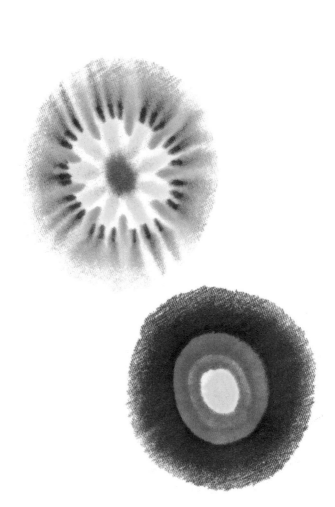

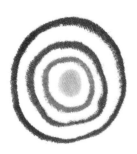

Small and large dots, parallel, wavy, and radiating lines—they all produce different effects, and they're fun to create on paper as well as fabric! Play around with different marks and manipulating your markers, and embrace the unexpected beauty that you can create.

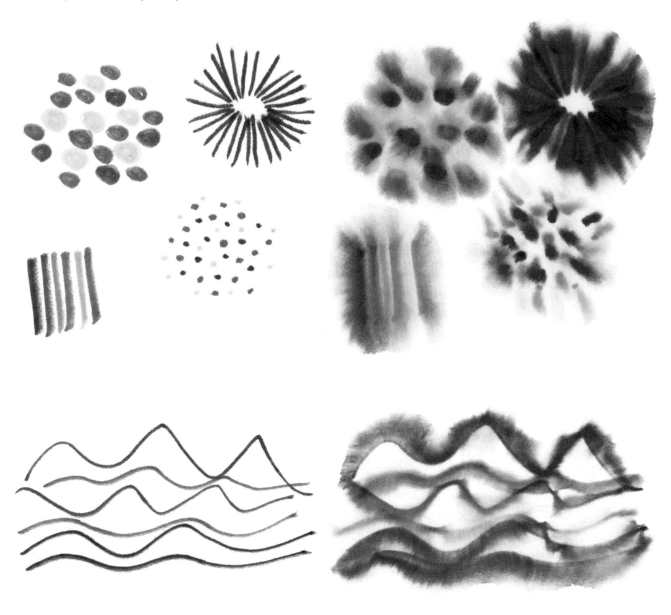

REMEMBER THE PRINCIPLES OF COLOR THEORY (SEE "COLOR BASICS" ON PAGE 10), AND USE COLORS THAT SIT CLOSE TO EACH OTHER ON THE COLOR WHEEL AND MIX WELL TO AVOID CREATING A MUDDY MESS!

Try creating some fun patterns and designs here before transferring them onto your watercolor paper or fabric and adding rubbing alcohol.

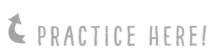 PRACTICE HERE!

IT'S ALL IN THE DETAILS

Once you've mastered using markers and rubbing alcohol to create watercolor effects, it's time to add some details!

Wait until your "watercolors" are completely dry, and then grab your permanent markers, paint markers, or fineliners, and add some details on top.

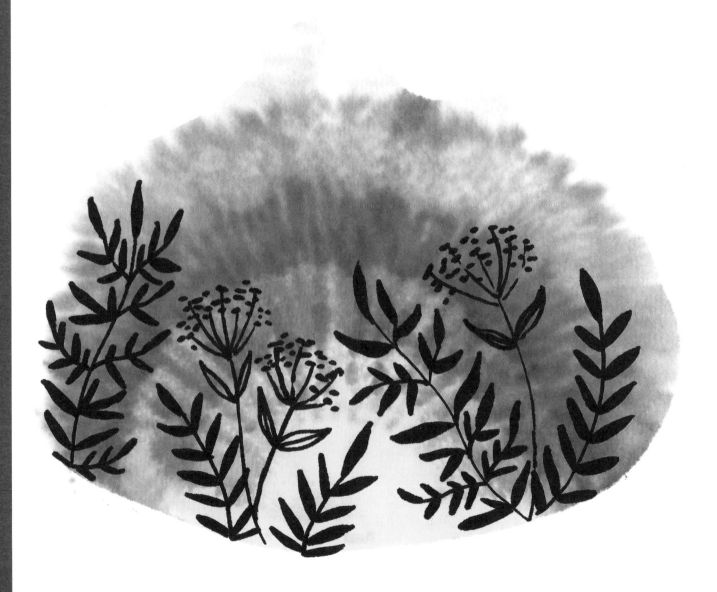

Use your experiments from the
previous pages, or create new
designs for your images.

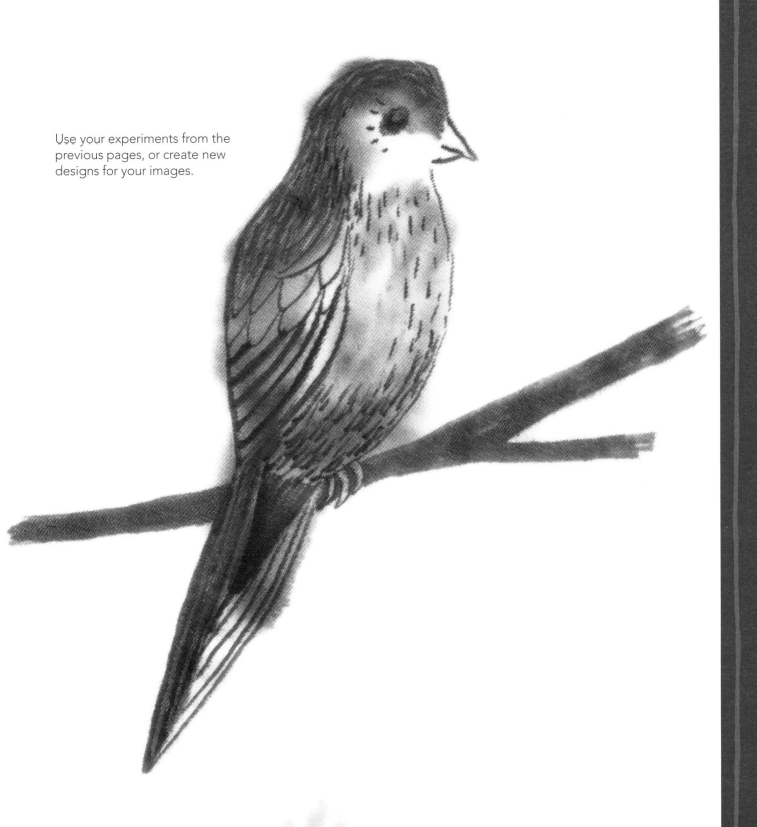

If you're stuck on what to draw, flip back to "Drawing Inspiration from Nature" on page 28 and "Simplifying Shapes" on page 30. Start with simple shapes and just a few colors, and add rubbing alcohol to create interesting, unexpected effects.

 PRACTICE HERE!

MAKING MANDALAS

A mandala is a circular symbol that represents the universe in Hinduism and Buddhism. Its shape makes it perfect for this project, which will teach you to create artwork inspired by a mandala that's then framed in an embroidery hoop. Watch as the droplet of rubbing alcohol spreads over the marker's ink and pulls it outward into a colorful circle—it's a fascinating process!

TOOLS & MATERIALS

- White fabric
- Embroidery hoop
- Permanent markers in various colors
- Rubbing alcohol
- Colorful fineliner markers
- White or pale-colored paint marker
- Pipette
- Scissors
- Well-ventilated area to work in!

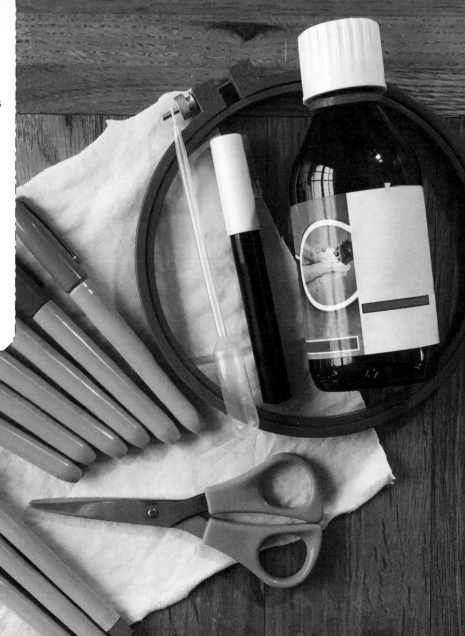

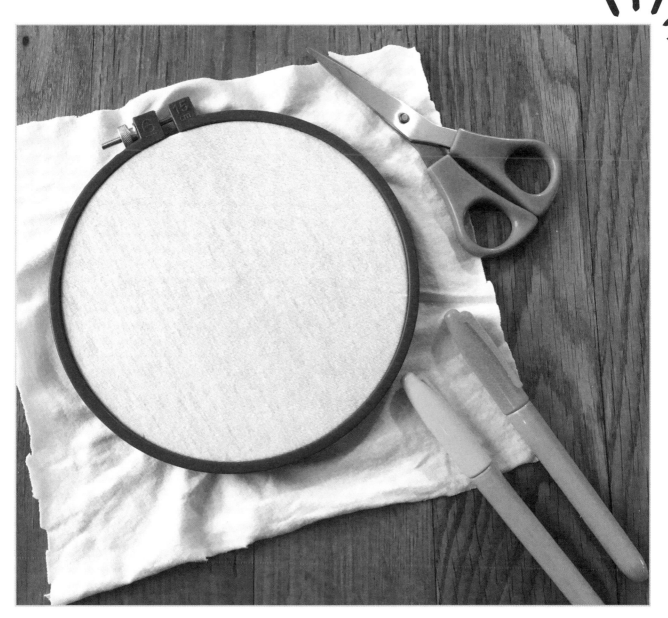

Step 1 Start by mounting the fabric in an embroidery hoop. Loosen the clasp on the hoop to separate it. Sandwich the fabric between the two hoops, tighten the hoop, and pull the fabric fairly tight. Then tighten the clasp all the way and pull the fabric to remove any saggy areas or creases around the edges.

EMBROIDERY HOOPS COME IN WOODEN VERSIONS AS WELL AS COLORFUL PLASTIC ONES. WHY NOT MATCH YOUR MARKER COLORS TO YOUR HOOP?

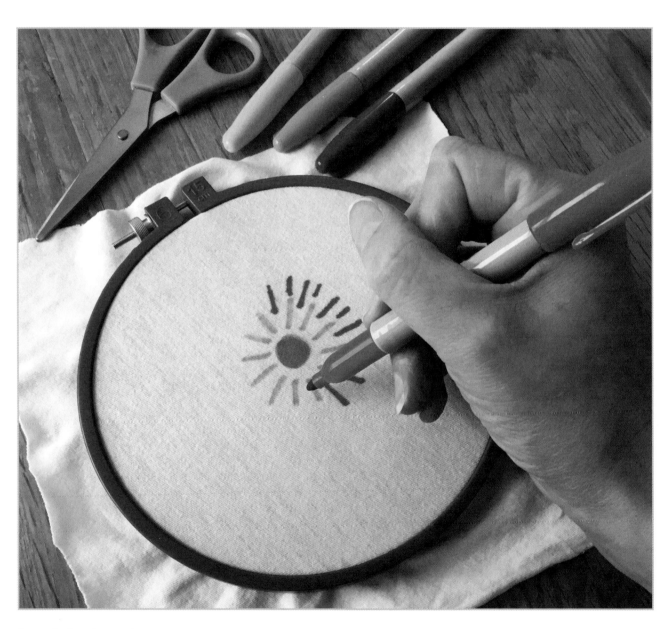

Step 2 Starting in the very center, use permanent markers to draw your design onto the fabric with marks that radiate outward.

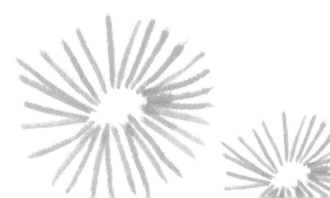

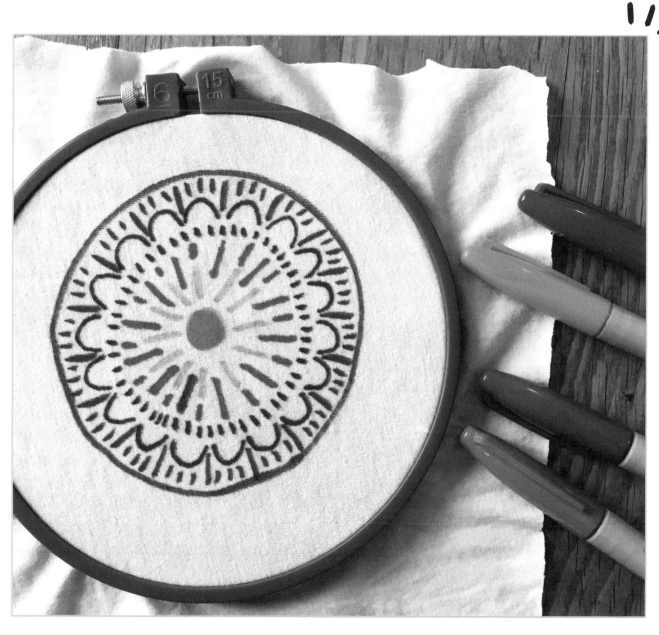

Step 3 For the best results, work from light to dark, and use a range of marks, from small dashes and curves to a consistent circular line.

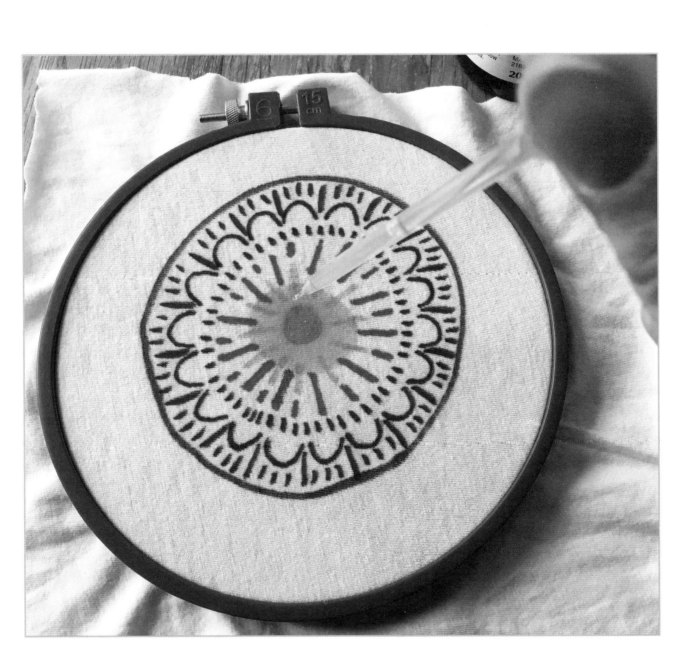

Step 4 Drop some rubbing alcohol in the center of your design, and watch the colors spread. You may need to add more drops to spread the colors toward the edge of the fabric.

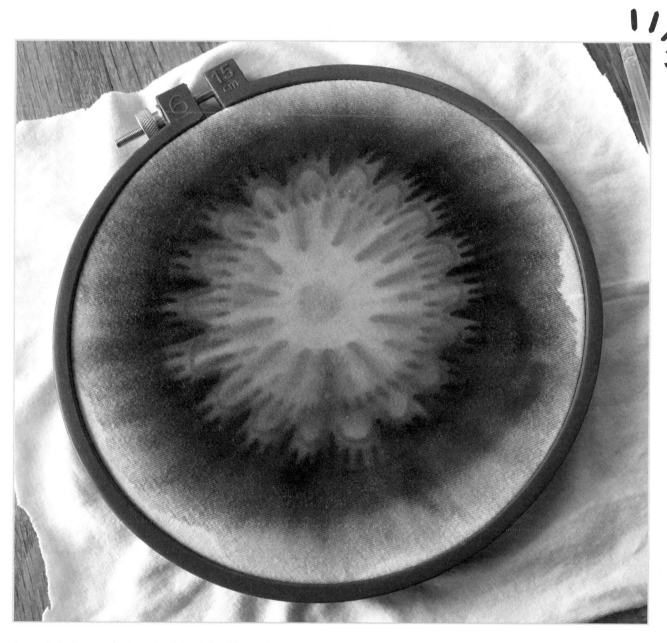

Step 5 Let your design dry. The ink will continue
to spread as it dries.

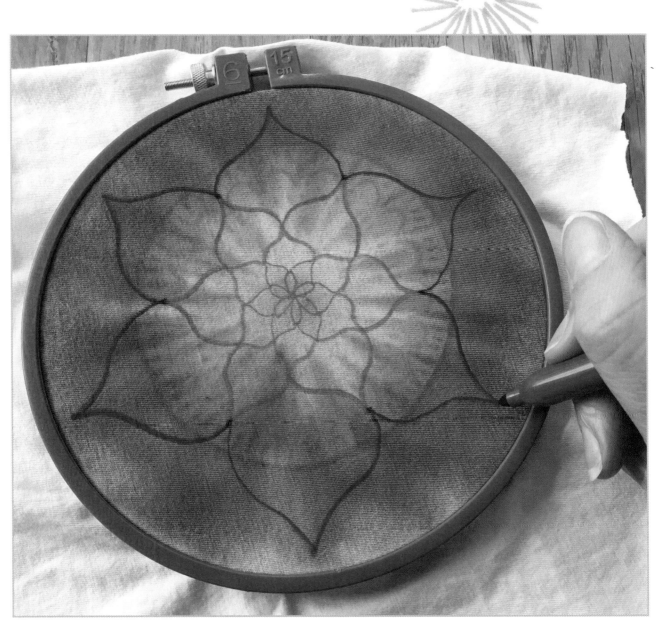

Step 6 Now use your fineliner pens to draw a circular pattern over your design. I drew radiating petals using slightly darker colors than the ones in my design.

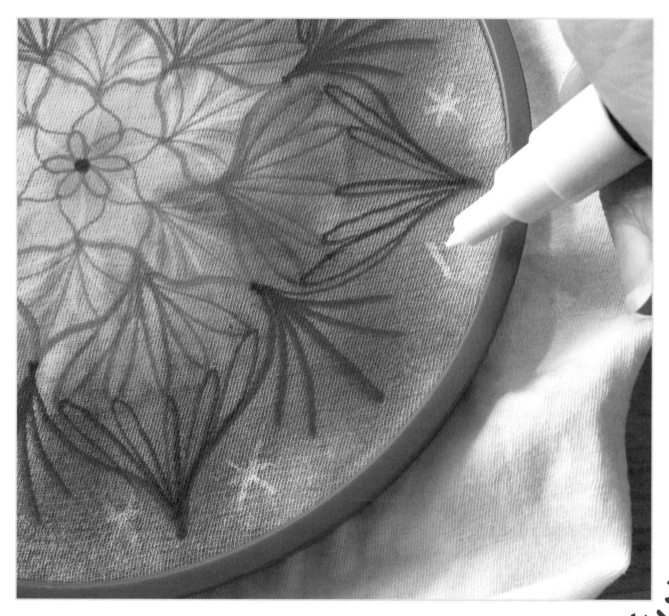

Step 7 Use the paint marker to add more details, such as stars around the edge of your design and/or embellishments within the mandala.

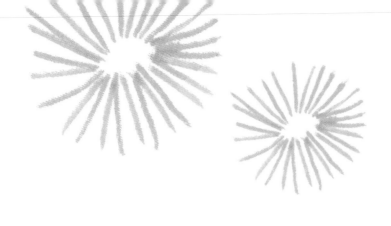

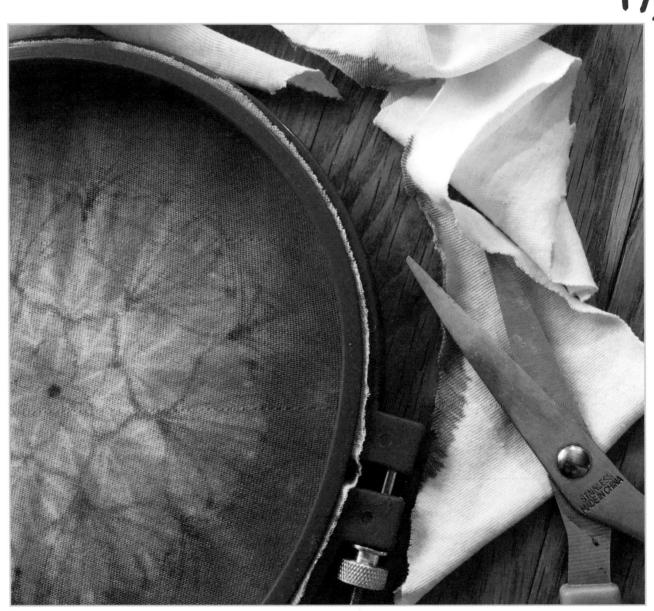

Step 8 Double-check that the hoop is as tight as you can make it, and then turn it over to trim off any excess fabric. Then hang your finished mandala to display your handiwork!

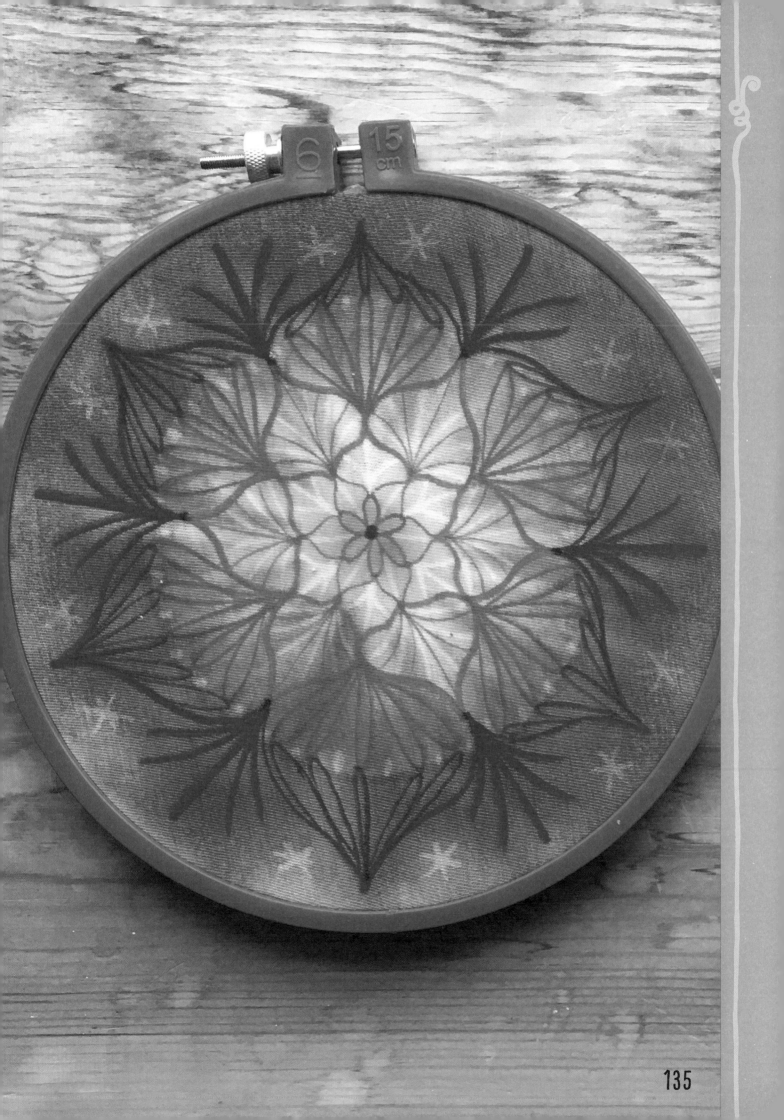

IDEA GALLERY

We're bursting with ideas!

Once you've completed the creativity prompts, exercises, and step-by-step projects in this book, you can also try these projects if you're looking for even more ways to create art using markers.

Share photos of your results online, or hand them out as beautiful, homemade gifts that your friends and family are sure to love. Make sure to personalize your projects to match your own hobbies, favorite colors, and home décor.

WOODEN DOOR SIGNS

Handmade door signs are a great way to add individuality to a child's bedroom door or wall.

I used wood slices and turned them into door signs featuring my kids' initials. After decorating them with some of my children's favorite things, I added a light coat of varnish.

Hang your signs by applying a small picture hook or strong, double-sided adhesive to the back.

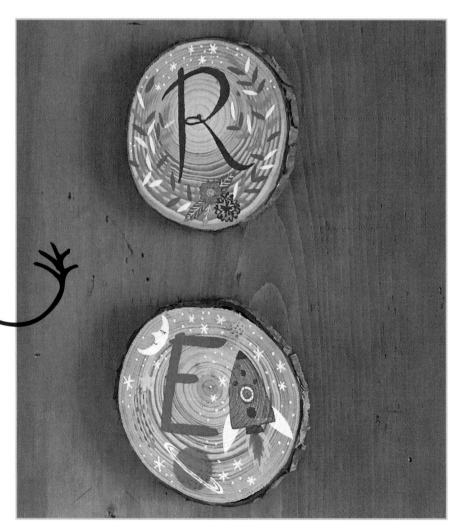

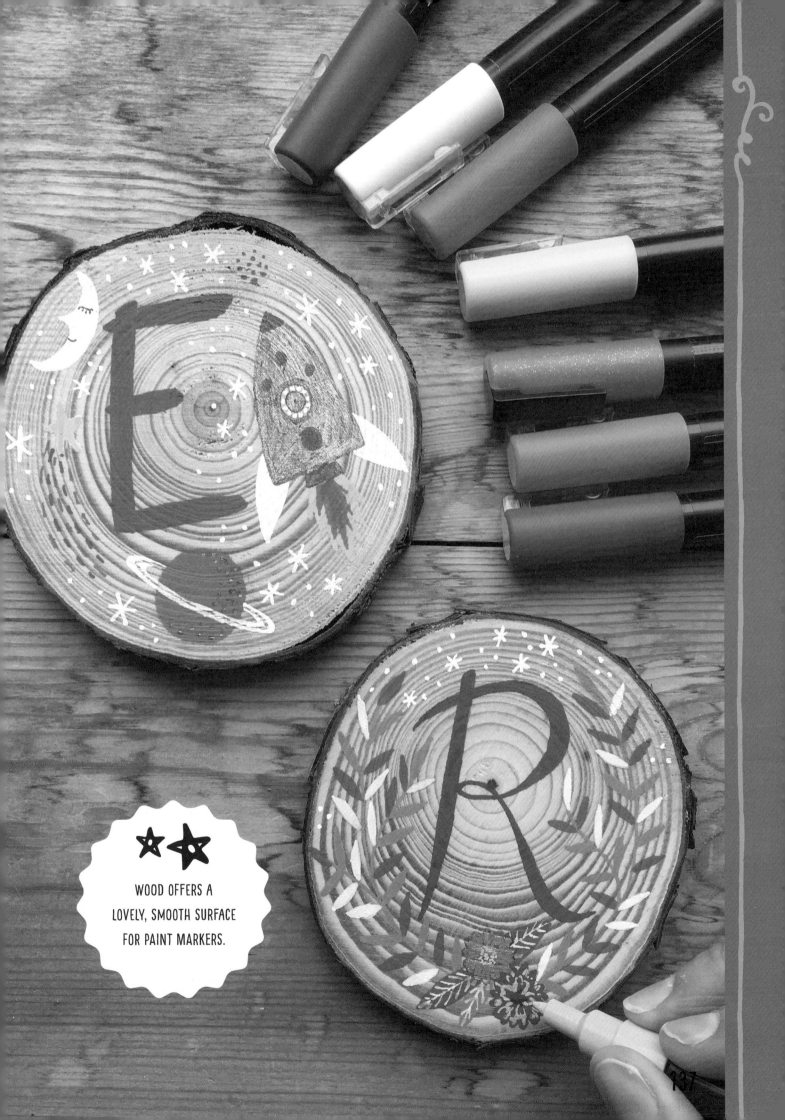

WOOD OFFERS A
LOVELY, SMOOTH SURFACE
FOR PAINT MARKERS.

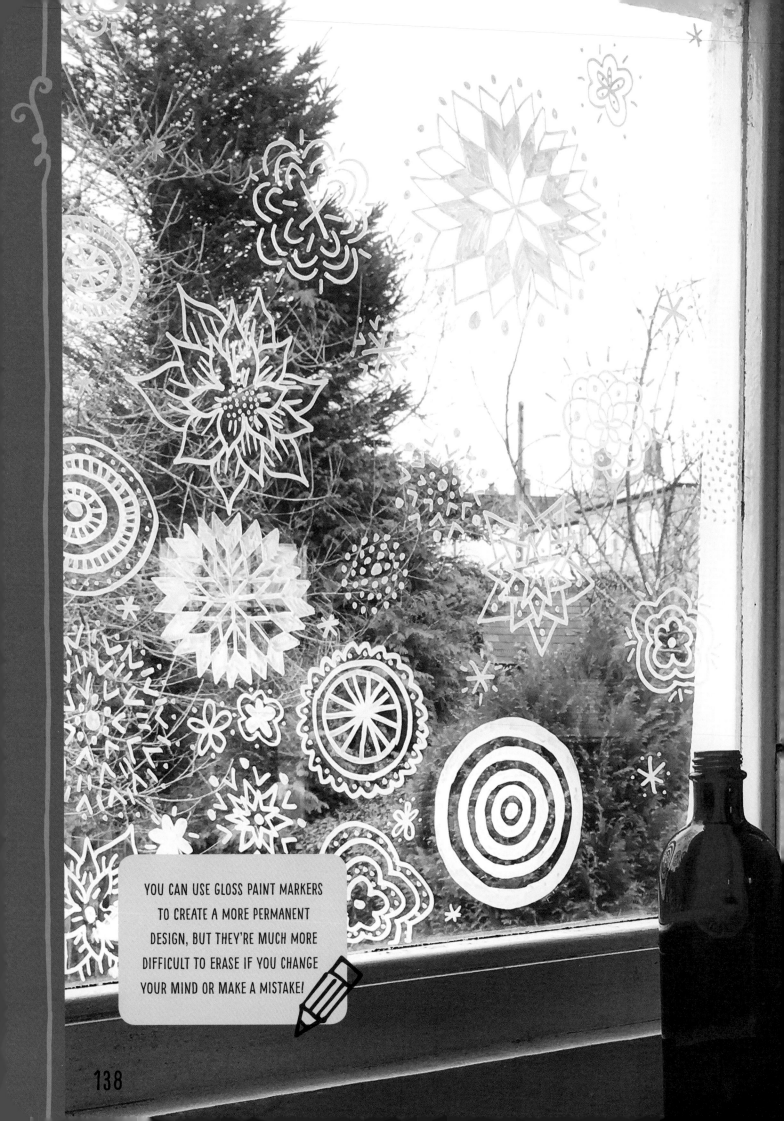

YOU CAN USE GLOSS PAINT MARKERS TO CREATE A MORE PERMANENT DESIGN, BUT THEY'RE MUCH MORE DIFFICULT TO ERASE IF YOU CHANGE YOUR MIND OR MAKE A MISTAKE!

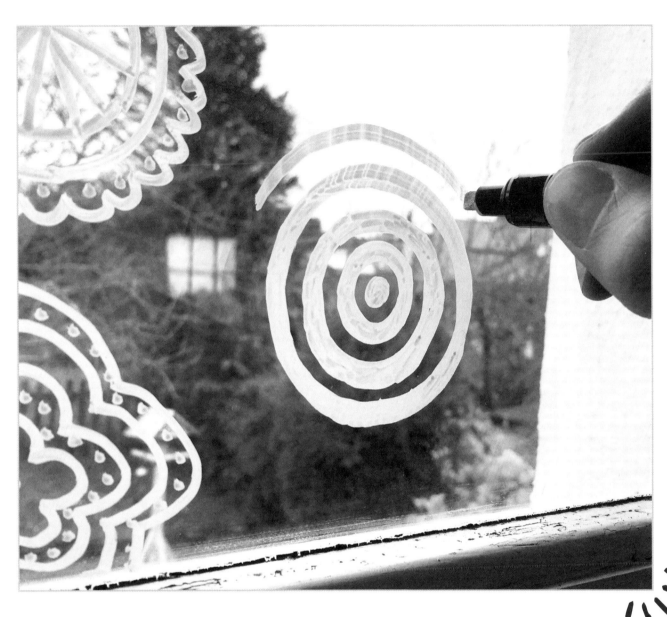

WINDOW ART

If you'd like to add extra decorations to a room to celebrate the holidays or a birthday, try getting creative with your windows!

Chalk markers are widely available and can easily be washed off using just a damp cloth and a light cleaning liquid. Their results will look particularly striking both inside and out.

Try doodling swirling shapes or a little scene. Just remember that if you want your art viewed primarily from the outside, everything will need to be drawn in reverse. This is especially important if you add lettering to your art!

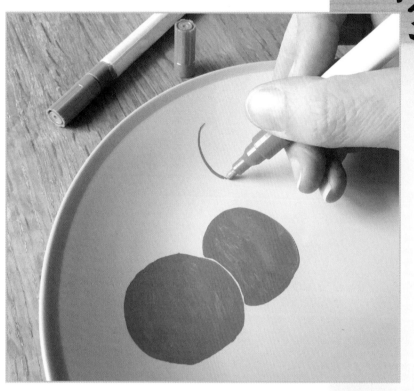

PLATE ART

Hand-drawn plain white ceramic plates can be displayed on a shelf, or you can fill an entire wall with an eclectic mix of styles!

Purchase the plates online or in your local hardware store, and use gloss paint markers to draw on them. The plates don't have to be white; gloss markers are opaque and will draw on colorful surfaces as well. So get creative with your plate colors as well as your markers! A colored rim adds another fun detail to your art, and it can help inspire your color palette.

THESE PLATES ARE FOR DECORATIVE USE ONLY; DO NOT EAT OFF OF THEM!

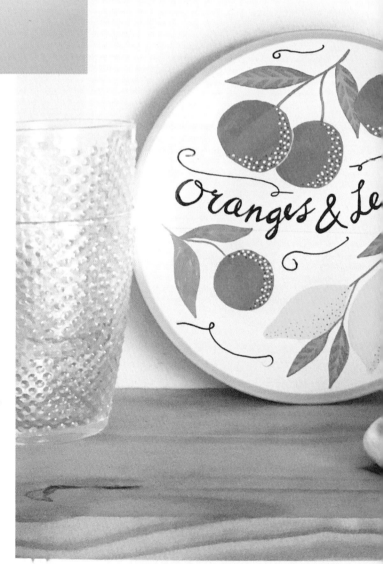

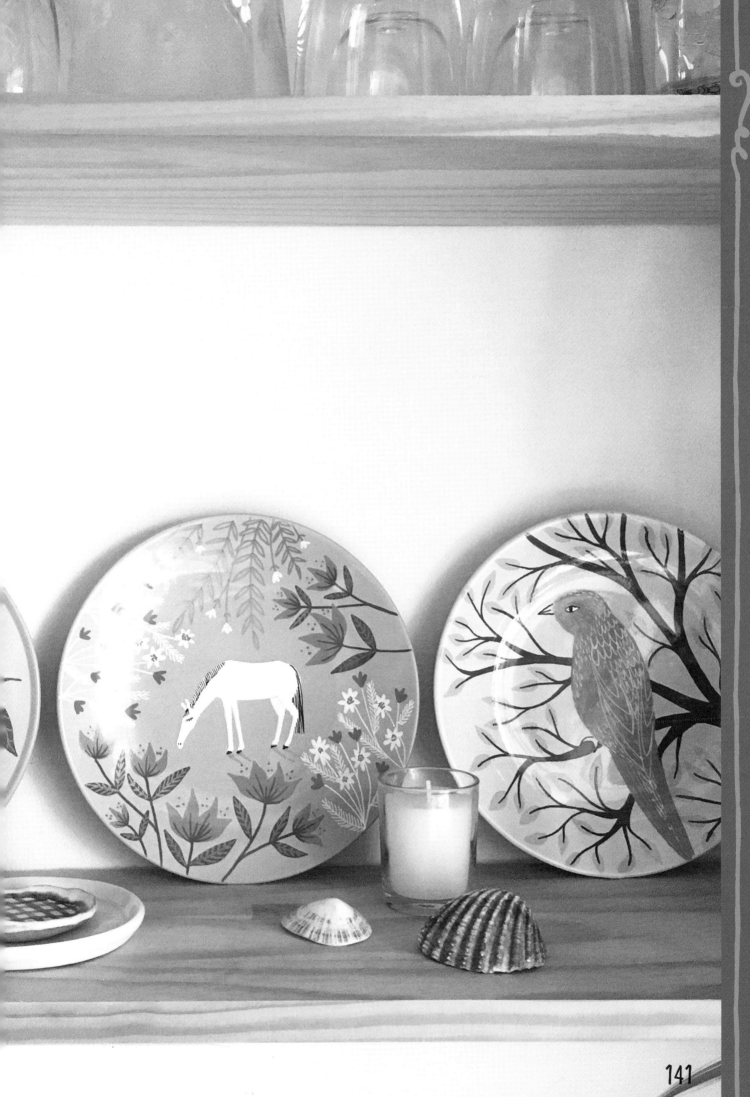

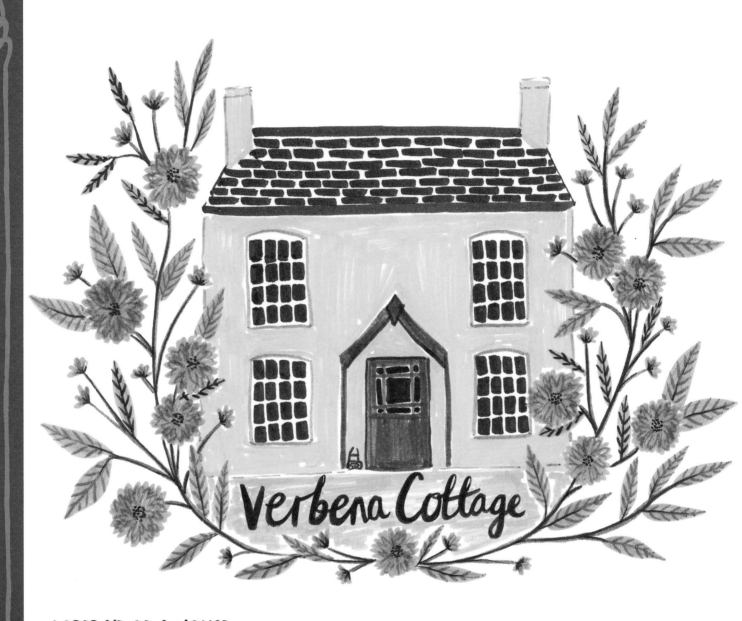

PORTRAIT OF A HOUSE

A hand-drawn portrait of their home makes a wonderful, sentimental gift for someone who's just moved or a couple moving into their first home together.

Snap a photograph of the home, and then draw it using the markers of your choice. Feel free to take some artistic license to make it especially decorative! Add floral elements from the garden, if there is one, or draw items that represent the residents' hobbies, such as a bike if they're cyclists or rain boots lined up outside the door if they love the outdoors. Perhaps use hand lettering to add the name of the house too!

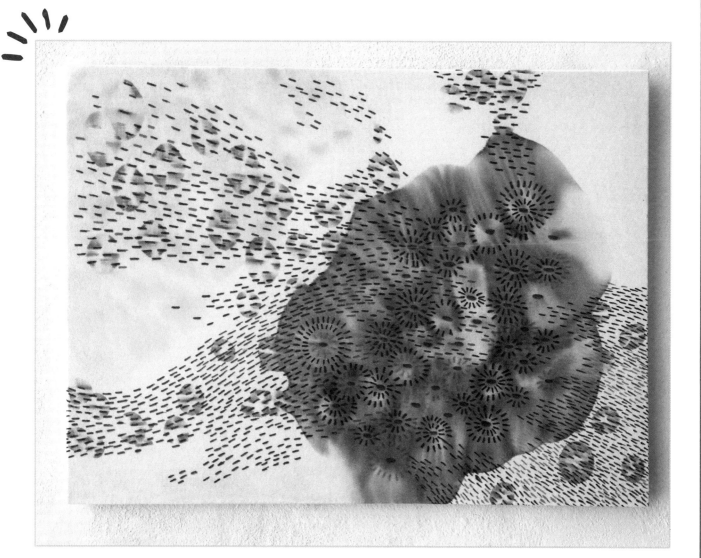

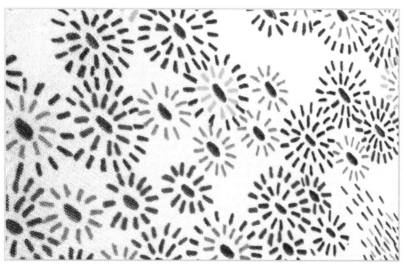

TO RID YOUR ARTWORK OF THE SMELL OF RUBBING ALCOHOL, LEAVE IT OUTSIDE ON A DRY DAY. THE ODOR WILL DISAPPEAR COMPLETELY WITHIN A SHORT WHILE!

LARGE-SCALE ART PIECE

You can also create large-scale art pieces using markers! To do this, I used permanent markers, a pipette, rubbing alcohol, and thick jersey fabric that I stapled around a frame. Then I used the same technique that I described in my creativity prompt on page 118 to create an abstract piece.

ABOUT THE AUTHOR

Lee Foster-Wilson is an artist and illustrator living and working by the sea in rural Cornwall, England, with her husband and young family.

In her artwork, Lee likes to explore patterns, rhythms, stories, the connection of people to nature, and our relationships with each other. Her art can be found on cards, prints, apparel, accessories, and jewelry.